RESIDUE
THE PERSISTENCE OF THE REAL

Vancouver Artgallery

black dog publishing
london uk

CONTENTS

Brian Jungen and Duane Linklater
Modest Livelihood, 2012 (still)

4

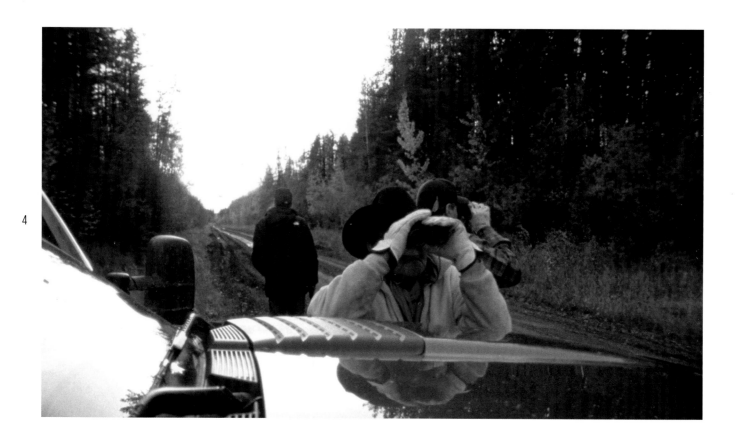

DIRECTOR'S FOREWORD
KATHLEEN S. BARTELS

The term "documentary," which originated in the late 1920s, has a long-standing history in the world of culture. Though the premise that an image can reveal the full truth of a situation it depicts has been deeply questioned, interest in artworks that describe the world has proven to be exceptionally resilient. Over the past two decades the possibilities, contradictions and paradoxes of documentary have formed one of the most vital arenas of activity and debate in contemporary art.

The Vancouver Art Gallery is proud to present *Residue: The Persistence of the Real*, an exhibition of recent work that represents the vitality of documentary's expanded field. Comprising photography, film and video, it features eight artists from Canada and the United States: Robert Burley, Stan Douglas, Babak Golkar, Geoffrey James, Brian Jungen and Duane Linklater, Catherine Opie, and Amie Siegel. Although diverse in approach and subject matter—which ranges from Opie's photographs of Elizabeth Taylor's closets to Jungen and Linklater's meditative portrayal of a moose hunt—the work that makes up *Residue* is marked by a desire to authentically represent the world around us, while also acknowledging the play between artifice and truth.

This exhibition and publication have been made possible through the generous support of many individuals. I extend my deep gratitude to Gallery Trustee Lisa Turner and her husband Terrence, and to Bruce Munro Wright, Chair of the Gallery's Board of Trustees, for their contribution to the realization of this exhibition. I also greatly appreciate the ongoing support we receive from the Richardson Family, our Visionary Partner for Scholarship and Publications. My sincere thanks to the artists, collectors and commercial galleries who have kindly loaned artwork to the exhibition. I also acknowledge Black Dog Publishing, especially Duncan McCorquodale, Ana Teodoro and João Mota for their work in creating this wonderful publication.

I am profoundly indebted to the Vancouver Art Gallery's Board of Trustees and the Gallery's staff for their exceptional commitment to our programs, particularly Grant Arnold, Audain Curator of British Columbia Art, for his outstanding work on this exhibition and his thoughtful contributions to the publication. Most importantly, I extend my heartfelt appreciation to all of the artists participating in the exhibition—without their unique and compelling visions, *Residue: The Persistence of the Real* would not be possible.

5

Geoffrey James
Poster designed by inmates, 2013

INTRODUCTION
GRANT ARNOLD

Residue: The Persistence of the Real brings together bodies of recent work by eight artists from Canada and the United States that, in various ways, are marked by a documentary impulse. Such a claim is not intended to imply a direct equivalence between the activities of these artists or to erase differences in their practices. While each exploits the camera's descriptive power to claim an anchorage in the larger world, their approaches to lens-based media are diverse and photography, film and video's roles in their practices vary. Some of these artists would not characterize their practices as documentary per se, while for others the term is a relatively comfortable fit. Robert Burley, Geoffrey James and Catherine Opie have each worked exclusively with still photography for more than two decades, producing impressive corpuses comprised of thematic projects that have overt connections to a documentary tradition—although they also push discretely at its limits through their choice of subject matter, their layering of meaning and their deliberate evasion of an overarching narrative. Both Stan Douglas and Amie Siegel work with film, video and photography to draw upon the history of cinema and the representational regimes associated with documentary, engaging with modernity's explicative structures and connective currents. Brian Jungen and Duane Linklater's collaboration on film projects is a relatively recent undertaking; both maintain individual practices and work in a variety of media to engage with the cultural displacement and recovery that is associated with the persistent and ongoing colonial condition that marks the relationship between Euro-Canadian culture and the first peoples of this country. *The Return Project* is the first body of Babak Golkar's work in which photography plays a significant role in extending the thematics of his previous projects that employed sculpture, drawing, ceramics and architectural installation to consider the configuration of space and the relationship between disparate accounts of history and contemporary cultures.

Documentary is a vexed and slippery term that has been applied to artworks that vary significantly in their authors' intents and the contexts in which they circulate. For a variety of reasons, debates on the origins, contradictions and potential of documentary have taken an increased prominence in the art world over the past two decades, a turn that can be seen in the escalating attention given to documentary artwork in international biennials, its increasing inclusion in the collections of art museums and its growing presence in art schools' course offerings. This configuration is in part responsible for the shift in the status of photography, video and film over the past twenty years, from subordinate media to an area of activity with status equivalent to that of painting and sculpture. Nevertheless, as art historian Olivier Lugon has noted, documentary "has always encompassed varying images and attitudes and given rise to contradictory definitions...No one has ever known with certainty what the term 'documentary' actually entails."[1] Lugon traces its origin as a classification of images to early twentieth-century France, where "film documentaire" was associated with "a cultural or travel film of an edifying character" and the documentary properties of a photograph were linked to questions of archiving and inventorying cultural heritage, an endeavour epitomized in the mid-nineteenth century survey of the country's architectural patrimony undertaken by the Missions Héliographiques. Although the work of photographers such as John Thomson and Jacob Riis had been associated with social reform movements in the late nineteenth century, it was only in the 1920s and 30s when filmmakers and photographers working in Britain and the US began to use film and photography for "combative purposes"—to draw widespread public attention to social inequity—that documentary came to signify an idiom of work "geared to the non-stage-managed contemporary world, and social reality in particular. Accordingly, the term acquired an extremely positive moral and political connotation associated with the quest for truth and social commitment."[2] This new association marked a fundamental change in the

connotation of the term, shifting it from the stability of an archival record to the more precarious state of a discursive field.

The first English-language application of the term documentary to visual media is widely ascribed to the Scottish-born filmmaker, producer and critic John Grierson. In his 1926 review of Robert Flaherty's film *Moana: A Romance of the Golden Age*—a sort of docudrama that claimed to authentically portray traditional life on the Samoan island of Savai'i—Grierson located "documentary value" in the film's "visual account of events in the daily life of a Polynesian youth and his family."[3] Grierson did not suggest Flaherty's film was documentary in form and he later criticized it for what he saw as its retreat from the contemporary world into "exotic escapism." Nevertheless, he argued that Flaherty's extended engagement with the culture of Savai'i, his use of the island's inhabitants—rather than professional actors—in the cast, together with his "absolute principle" that "the story must be taken from the location," pointed the way for a new mode of cinema that was emerging in Britain and the US during the period between the First and Second World Wars.

Closely associated with the rise of the British documentary film movement in the mid to late 1920s, Grierson became the most influential proponent of documentary film in the English-speaking world over the following two decades. From the late 1920s to the mid-1940s he served as the head of various official government agencies, including the Empire Marketing Board's (EMB) film unit, which was founded in 1927 and became a division of the General Post Office (GPO) in 1933; from its founding in 1939, he acted as the commissioner of the National Film Board of Canada, until he was forced out in 1945. Grierson personally directed only two films: *Drifters* (1929) and *Granton Trawler* (1934). His far-reaching influence on documentary cinema's form was due primarily to his role as an impresario, a theorist and the producer of more than fifty films, with the various agencies he led completing hundreds of documentary films during his tenure. As head of the EMB and GPO film units he assembled an ambitious group of young filmmakers, music composers and poets that included Basil Wright, Humphrey Jennings, Benjamin Britten and W.H. Auden, in pursuit of "a new and vital art form" in which the camera's capacity to depict "the living scene and the living story" of the real world would run counter to the escapism and "shim-sham mechanics" of the Hollywood feature film.[4] For Grierson, authenticity and emphasis on the everyday were paramount. He argued against the use of professional actors and the illusion of the feature film set, asserting that "the original (or native) actor, and the original (or native) scene are better guides to a screen interpretation of the modern world" and "the materials and the stories thus taken from the raw can be finer (more real in the philosophic sense) than the acted article."[5]

The birth of the documentary film in Britain was bound to a historical moment when the nature of British politics—on a domestic level—was undergoing fundamental change. The conclusion of the First World War—during which the British government began to assume control over a wider range of social policies—and the corresponding extension of the right to vote to most working class men and most women over the age of thirty, radically shifted the relationship between the state and the citizen. This shift brought with it a new vocabulary in which terms like "general public" and "public opinion" implied a regard for the views of the population at large that was very much at odds with the traditional hierarchies of British politics, obliging the governing political party to pay exponentially greater attention to public opinion.[6] As Sir Stephen Tallents, the first secretary of the EMB who hired Grierson to work for the agency's film unit, put it: "Today the state is always being called upon by Parliament to undertake new tasks of organization and to provide new services. At the same time the Government has to win consent for its actions, and to secure assistance in carrying them out from a much greater electorate than even twenty years ago."[7]

Film's potential as a vehicle to shape public opinion was quickly recognized across the spectrum of British politics. From the mid-1920s to the late 1930s, the British Conservative Party treated film as its most

valuable propaganda weapon, using a fleet of daylight cinema vans that could show films in the street at any time of the day to reach working-class audiences. These included "Felix-the-Cat type cartoons 'ridiculing the policy and tactics' of the Labour Party [as well as] other short films [including] speeches by Conservative Party Leaders...and live-acted dialogues between 'working men' in which one actor demonstrated to another why conservativism was best."[8]

While it was a Conservative government that established the Empire Marketing Board, the staff of the board's film unit, including Grierson, was comprised of primarily middle-class intellectuals with socialist leanings. Unfettered by the necessity of generating box office revenue, Grierson saw documentary cinema as the ideal means of mass education and propaganda, serving as a vehicle that could inform a broad public and enable the citizenry to comprehend and respond to matters that were essential to the development of a democratic society. This involved creating a system of circulation outside of the film theatre and, by the time of its dissolution in 1933, the EMB was making 800 films available to film clubs, women's organizations, schools and community centres on an annual basis.[9] As Bill Nichols has put it: "For Grierson, the value of cinema lay in its capacity to document, demonstrate, or, at most, enact the proper, or improper, terms of individual citizenship and state responsibility."[10] In this context documentary did not equate to objectivity or detachment. The filmmakers who worked with Grierson generally shared in the progressive politics of the period, and often focused on the difficult living conditions of the British working class. An uninflected, naturalist inscription of reality was neither possible nor desirable: documentary film was "the creative treatment of actuality"—it was authored, not simply registered or inscribed.[11] As Grierson said: "It is important to make the primary distinction between a method which describes only the surface values of a subject, and the method which more explosively reveals the reality of it. You photograph the natural life, but you also, by your juxtaposition of detail, create an interpretation of it."[12]

Grierson was well aware of the parallels between his vision of the social value of documentary film and the achievements of Soviet filmmakers during the 1920s. He played a key role in arranging for Sergei Eisenstein's first film, *Strike* (1924), to be distributed in the US; he contributed the English subtitles to Victor Turin's *Turksib* (1929); and *Drifters* was first screened as part of a double bill with Eisenstein's *The Battleship Potemkin* (1925)—which was banned from general release in Britain at the time—at the London Film Society in 1929. Grierson and his colleagues at the EMB and GPO acknowledged a debt to the work of Soviet filmmakers; however, by the mid-1930s Grierson was cautioning against what he saw as a preoccupation with radical formal innovation for its own sake at the expense of intelligible narrative or educational merit:

> [The] Russian directors are too bound up—too aesthetically vain—in what they call their "play films" to contribute to Russia's instructional cinema. They have indeed suffered greatly from the freedom given to artists in a first uncritical moment of revolutionary enthusiasm, for they have tended to isolate themselves more and more in private impression and private performance...One's impression is that when some of the art and all of the bohemian self-indulgence have been knocked out of them, the Russian cinema will fulfill its high promise of the late twenties.[13]

The complex relationship between British documentary and Soviet avant-garde cinema is readily apparent in *Drifters*, a silent, feature-length production sometimes cited as the first British documentary film. *Drifters* focuses on a crew of North Sea herring fisherman and the benefits brought on with the industrialization of the fishery. Like Eisenstein's *The Battleship Potemkin*, there are no long takes; scenes are cut up and montaged together in a cadence that parallels the heaving of the ship's deck and the repetitive rhythm of its engine components—an emblem of industrialization's productive potential—as the crew navigates the storm-tossed sea. However, as Jack C. Ellis has pointed out, *Drifters* also carries reflections of Flaherty's *Nanook of the North* in its portrayal of brave men eking out their existence in the face of the elements, but tempers Eisenstein's

9

heroics and Flaherty's emphasis on the exotic to address the conditions of contemporary working-class life: "In *Drifters* the drama is in the everyday workday. By ending on the fish being sold at market, Grierson sets the fishermen's work within the context of the economic actualities of contemporary Britain."[14]

Grierson's model of the documentary film provided the central reference for an account of documentary photography outlined by Beaumont Newhall in an essay published in the March 1938 issue of the journal *Parnassus*. Titled "Documentary Approach to Photography," Newhall's text specifically cited Grierson's review of *Moana*, noting that over the twelve years following the review's publication the term "documentary" has been "generally accepted among movie makers as defining a particular type of film which is based upon natural factual material (as opposed to artificial studio sets) presented in an imaginative and dramatic form." He went on to note: "I believe that the present popularity of the word to describe a class of still pictures has been inspired by the example of cinema." Newhall's text was less of a polemic than Grierson's 1932 essay "First Principles of Documentary," in which consideration of documentary film is tied to a vigorous denunciation of the Hollywood feature film, although Newhall does disparage the work of "photographers who have deliberately set out to rival or equal the painter" through the "slavish imitation" that had come to characterize idioms such as Pictorialism.[15] Newhall was less concerned with the role of photography in the larger culture than on tracing a lineage of documentary photography that extended from Henri Le Secq and Charles Marville (who did not consciously situate their work as art, according to Newhall), through Eugène Atget and Lewis Hine, to the work of young American photographers such as Berenice Abbott, Margaret Bourke-White, Walker Evans, Ben Shahn and Ralph Steiner (among others) who "sensing the artistic strength of such photographic documents as these [photographs by Marville, Atget and Hine], have seen in this materialistic approach the basis for an esthetic of photography."[16]

Newhall claimed that documentary was "an approach rather than an end," and while the documentary photographer was a purist in terms of technique, avoiding retouching of any kind, "he does not limit himself to any one procedure." His description of the working method of the documentary photographer closely followed that of the documentary filmmaker on assignment. Clarity in approach was crucial, and he advocated the development of a shooting script in collaboration with a journal editor prior to making the photographs. For Newhall, the documentary photographer was not a solitary artist in pursuit of an autonomous art, but was:

> First and foremost...a visualizer. He puts into pictures what he knows about, and what he thinks of, the subject before his camera. Before going on assignment he carefully studies the situation which he is to visualize. He reads history and related subjects. He examines existing pictorial material for its negative and positive value—to determine what must be re-visualized in terms of his approach to the assignment, and what has not been visualized.[17]

Emphasizing the importance of sociological purpose to documentary photography, Newhall echoed Grierson's vision of documentary as a tool of education (although Newhall was careful not to use the term "propaganda"), and argued that the documentary photographer will not be "dispassionate, but will put into his camera studies something of the emotion which he feels toward the problem, for he realizes that this is the most effective way to teach the public he is addressing."[18]

Like Grierson, Newhall acknowledged the importance of support from government agencies, with the American Farm Security Administration (FSA) taking on a role parallel to that of the Empire Marketing Board in Britain, but made no mention of the obligations that might be attached to such patronage. For him, the formation of the FSA's photography division was crucial for the development of documentary photography in the US. The work produced for the FSA by Evans and Shahn, Newhall argued, provided the model for the FSA's photographic survey of the dire conditions tenant farmers faced and set high technical

and aesthetic standards that both maintained "the primary sociological purpose of their survey" and deserved "the consideration of all who appreciate art in its richest and fullest meaning."[19]

"Documentary Approach to Photography" appeared at a transitional moment in Newhall's struggle to locate photography within the context of the art museum. A year prior to the essay's publication Newhall had organized *Photography: 1839–1937*, the first North American exhibition to attempt an overview of the history of photography, for the Museum of Modern Art in New York. Made up of more than 800 objects arranged according to photographic process (daguerreotype, calotype) and application (press photography, X-ray photography, "creative" photography) the exhibition, as Christopher Phillips has argued, was:

> ...frankly uninterested in the old question of photography's status among the fine arts; rather it signaled MoMA's recognition that implicit in photography's adoption by the European avant-garde was a new outlook on the whole spectrum of photographic applications...[the organization of the exhibition] seems [to have been] guided more by Moholy-Nagy's expansive notion of *fotokunst* than by Stieglitz's *kunstphotographie*.[20]

Newhall's approach to the exhibition annoyed Alfred Stieglitz, who adamantly insisted upon the separation of fine art and applied photography and wouldn't allow any of his later photographs to be included in the exhibition. However, by 1940 Newhall had moved away from both the functionalist approach articulated in *Photography: 1839–1937* and the conception of photography as a tool for education outlined in "Documentary Approach to Photography," moving instead toward a view closely aligned with Stieglitz's conception of modernist photography, in which a transcendent emphasis on the personal expression of the artist/photographer could be realized through the "full use of the inherent characteristics of the medium of photography" in photographs that are, in the fullest sense of the word, "works of art."[21]

On the surface, "Documentary Approach to Photography" seems to embrace the medium's potential as an applied art, but Newhall's emphasis on the "emotion" of the photographer is indicative of an underlying and persistent tension between the mechanical nature of photography and the status of the photograph as an artwork, a tension heightened by the particular descriptive obligations attached to documentary photography. Perhaps in response to Ansel Adams' infamous complaint to Roy Stryker on the work of the FSA's photography unit and its role in supporting Roosevelt's New Deal—in which Adams claimed: "What you have aren't photographers, they're a bunch of sociologists with cameras"[22]—Newhall goes to some length to counteract the perception of the documentary photographer as a technician, arguing that the term documentary does not preclude individual expression:

> The pictures [of the documentary photographer] will have a different and more vital quality than those of a mere technician. They will even be better than those of a cameraman working under the direction of a sociologist, because he understands his medium thoroughly, and is able to take advantage of its potentialities while respecting its limitations. Furthermore, he is able to react to a given situation with amazing spontaneity.[23]

Thus, the basis of a documentary photograph as an artwork lay not so much in the photographer's intent, but in the knowledge of his or her subject matter, a thorough understanding of the technical parameters of the medium with which he or she was working and the ability to convey something of the "emotion" felt while perceiving the subject matter in front of his or her camera.

If the model established by British documentary filmmakers—their combination of fact, dramatic presentation and sociological purpose—was vital to Newhall, he was careful to point out fundamental differences in the nature of cinema and still photography. Film, he noted, is a temporal art: "film is always seen as a unit,

the sequence of images is prescribed, and remains uniform except for willful cutting for moral or economic reasons." In contrast, still photography is primarily temporal and, while Newhall saw books and journals as viable forms of circulation for documentary photographs, he acknowledged that the meaning of an individual photograph is less stable than in documentary cinema: "The still photograph...is seldom seen twice in a similar matter. It may be reproduced together with any other photograph, and with any caption." As a counter to this volatility, Newhall proposes extended captions for the image to enable "the beholder to orient himself, leaving the photographer free to interpret the subject more imaginatively," and the production of photographs in series, which he saw as "the richest manner of giving photographs significance, for each picture reinforces the other."[24]

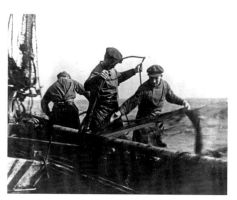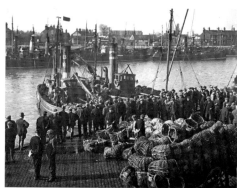

Drifters, 1929 (stills)
directed by John Grierson

While Newhall emphasized the importance of an agency like the FSA in the development of documentary photography, he made no mention of the New York Photo League, even though it had played a prominent role in defining documentary film and photography in the US during the 1930s and some of the photographers discussed in "Documentary Approach to Photography" had been active members in the League for some time. The League emerged out of the New York chapter of the Worker's Film and Photo League (WFPL), which was founded in 1930 with support from the Workers International Relief (WIR), an agency of the Communist International that had, in turn, been formed in Berlin in 1921. The WFPL attached an overtly political character to documentary film and photography. Its objectives included the production and exhibition of politically committed photographs, newsreels and films that would draw widespread attention to the dire conditions experienced by the American urban working class during the Great Depression. Following the model of the workers photography movement, which originated in Germany and the Soviet Union during the early 1920s with the objective of producing images of working-class life made by working-class photographers, the WFPL ran a school that focused on documentary film and photography, organized photography exhibitions, sponsored lectures and provided its members with access to equipment and darkrooms.

The majority of the WFPL's early film productions were newsreels focused on current events that were intended to challenge the accounts presented in large-circulation newspapers and the "official" newsreels that were often screened in cinemas along with Hollywood feature films. Their footage was shot, processed and edited quickly for screening in libraries, union halls and workers' clubs. At times the footage appeared later in more precisely edited documentaries, such as *Hunger* (1932), which included live footage of the National Unemployment March from New York to Washington. The WFPL made no claim of detachment, but produced its films to represent events and perspectives excluded from public discussion. As Samuel Brody, a founding member of the WFPL and film critic for the *Daily Worker*, commented on the production of *Hunger*: "we 'shot' the march not as 'disinterested' news-gatherers but as actual participants in the march itself. Therein lies the importance of our finished film. It is the viewpoint of the marchers themselves..."[25]

The WFPL went through several organizational changes over the following decade, as financial support from the WIR dissipated and the League's members pursued somewhat disparate documentary projects. In an indication of a shift in focus that extended beyond straightforward activism, the term "Worker's" was dropped from the organization's name in 1933, from which point it was known as the Film and Photo League (FPL). In late 1934, Steiner, Leo Hurwitz and Irving Lerner, who had become dissatisfied with the FPL's film unit's adherence to a kind of cinema vérité version of documentary, split off from the FPL to form Nykino, a production/discussion group named in honour of Soviet films that favoured a more nuanced engagement with social analysis through the use of dramatic re-enactments and unconventional editing. In an essay titled "The Revolutionary Film—Next Step" that appeared in the May 1934 issue of *New Theater*, Hurwitz acknowledged the importance of the FPL's "agitational" newsreels, which were "necessary because of the rigid censorship and the malicious distortion that the capitalist film companies use in their treatment of events relative to labor and labor's struggles," while arguing that the time had arrived for a new form of documentary film, "a mixed form of the synthetic document and the dramatic is the next proper concern of the revolutionary film movement: to widen the scope of the document, to add to the document the recreated events necessary to it but resistant to the documentary camera eye—a synthetic documentary film which allows for material which recreates and fortifies the actuality recorded in the document, and makes it clearer and more powerful."[26]

The departure of Steiner, Hurwitz and Lerner from the FPL was precipitated by their realization that "film as a dramatic medium cannot merely concern itself with external happenings, even though they be revolutionary happenings, but must embody the conflict of underlying forces, causes"and that the efficacy of their work depended on their ability to engage their audience on an emotional level. [27] As William Alexander has noted, the formation of Nykino marked an attempt—on the part of its members—to "improve their artifacts, to raise their standards to professional levels, and to reach a mature realism. The reasons were several: to help draw into the Popular Front movement accomplished artists less far to the left of center, to attract more than [a] very limited audience, and to deepen the political effects upon the audience [they] did reach."[28]

Nykino lasted only two years. Its productions included *The World Today* (1936), a left-wing response to *March of Time* (1935–51), a weekly newsreel program produced by *Time* magazine that screened in cinemas and combined standard journalism with dramatic re-enactments of events that had not been filmed live. The two sections of *The World Today* released by Nykino used actors and included an investigation of evictions in Queens and an exposé on a chapter of the Ku Klux Klan. In March of 1937 Nykino transformed into Frontier Films, which, in addition to Nykino's three founders, included Paul Strand, Willard Van Dyke, Jay Leyda, Henri Cartier-Bresson and the Dutch filmmaker Joris Ivens in its membership. Frontier completed four major films and several smaller-scale productions before it folded in 1942. The most significant of these was *Native Land* (1942), a feature-length documentary that combined actual footage and re-enactments of recent events that included a local sherrif's killing of sharecroppers who demanded a living wage and the torture of trade union supporters by the Ku Klux Klan. Incorporating Strand's cinematography with commentary by Paul Robeson, the film met—at least partly—its makers' intentions, as they were described in an anonymous review in the June 8, 1942 issue of *Time* magazine as "a shocking, stinging picture whose realism could never have been achieved in soft-stepping Hollywood."[29]

The internal tensions that led Steiner, Hurwitz and Lerner to the split from the FPL also contributed to the departure of the still photographers who left and formed the Photo League in 1936. Echoing Nykino's attention to documentary as art, the League showed "a commitment to documentary photography and its potential as an art form, not just a tool for mass communication or 'art as a weapon.'"[30] With the advent of the Popular Front, and its emphasis on cross-class cooperation in the fight against fascism, the stance of the League was more conciliatory than that of the WFPL. The League dropped the polemical attacks on

13

the Roosevelt administration and the New Deal programs that had run through much of the activity of the WFPL earlier in the decade and, although the work of League members continued to appear in left-wing journals such as the *New Masses* and *Daily Worker*, the organization no longer aligned itself directly with the labour movement.[31]

The Photo League's most ambitious project was the *Harlem Document*, which was undertaken between 1938 and 1940 by the Feature Group, a subgroup of the League led by Aaron Siskind that focused on the production of collaborative photographic essays depicting specific New York neighbourhoods and the visible contrasts between the wealth and poverty they contained. The *Harlem Document* was initially conceived by Michael Carter, an African American sociologist who collaborated with the Feature Group in assembling images for what was initially intended to be a book depicting contemporary life in Harlem.[32] The photographers were supplied with detailed shooting scripts, produced in collaboration with Carter, in which daily life was broken down into thematic sections—such as religion, housing, entertainment and children—so that the resulting images of tenement buildings, street life and nightclub dancers could serve as a means of drawing out the complex social relations that shaped Harlem life. The *Harlem Document* was emblematic of the League's conception of documentary as an idiom that functioned as social critique while allowing for personal expression. As Siskind noted in the 1940 issue of the League's journal *Photo Notes*, the photographer's control of the formal attributes of the image was central to engaging the viewer and conveying an intended meaning: "The literal representation of a fact (or idea) can signify less than the fact or idea itself...a picture or series of pictures must be informed with such things as order, rhythm, emphasis, etc....qualities which result from the perception of the photographer, and are not necessarily...the property of the subject."[33] A selection of the *Harlem* photographs were published in the July 1939 issue of *Fortune* magazine, which was intended to celebrate the New York World's Fair and provide its readers with a guide to the city. The section on Harlem featured eight photographs (three by Siskind and five by other members of the Feature Group) and an unattributed text (by Carter) that introduced the reader to the neighbourhood's geography, people and institutions in a tenor that radically departed from the celebratory spectacle of the World's Fair. Clearly intended as a terse introduction to Harlem for white readers, Carter described a community marked by "poverty, squalor and doubt," in "which nearly half the population is on relief" and "more than 90 per cent of Harlem buildings, shops, and businesses are owned and run by whites today...[who don't] employ the blacks. Eighty-five times in a hundred, when a Harlem cash register rings, the finger on the key is white."[34]

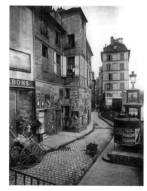

Eugène Atget
Rue des Ursins, 1900

Lewis Hine
A Young Spinner in a Southern Cotton Mill, c.1910

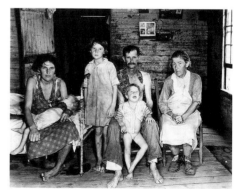

Walker Evans
Bud Fields and His Family, Hale County, Alabama, 1936

While the use of shooting scripts in the production of the *Harlem Document*, along with the inclusion of text that clearly articulated the sociological intent of the project, closely corresponded to Newhall's prescription for the presentation of documentary photographs, the images are placed in a subordinate role in the *Fortune* article. The page layouts—in which, for example, an image of a small apartment is accompanied by the term "squalor" and the images are butted up against one another—largely erased Siskind's interest in personal expression and left the images as the most basic form of document. As Joseph B. Entin has pointed out: "Because the photographs serve as secondary evidence...the formal and compositional dynamics of the pictures are de-emphasized in favor...of their ability to provide a factual truth that illustrates the quantitative, statistical documentation provided in the commentary."[35]

Another selection of the *Harlem Document* photographs appeared in the May 21, 1940 issue of *Look* magazine; however, the book for which the project was initially conceived was never published, Carter's text disappeared and the photographs received little attention over the following decades. In 1981, fifty-seven of Siskind's *Harlem* images were published in a monograph along with excerpts from the Federal Writers' Project's oral history of Harlem and a foreword by writer and filmmaker Gordon Parks, who grew up in Harlem. In this context the photographs operate very differently, shifting emphasis away from a collaborative examination of the mechanisms that shaped life in Harlem in the late 1930s and toward Siskind's sensibilities as an individual artist who embodies "intense humanity and exquisite sensitivity" in representing his subject.

With the onset of the Second World War, the documentary projects embodied in the New York Photo League, the Farm Security Administration and the film units of the Empire Marketing Board and the General Post Office became increasingly less viable. This was due in part to the dissolution of the agencies themselves. In Britain, the GPO film unit was taken over by the Ministry of Information and its resources were directed into the war effort. In the US, Frontier Films was dissolved in 1942 due to lack of funds, while the FSA's photography unit was disbanded the following year. Although it had become a largely non-political organization, the Photo League came under political pressure in the anti-communist purges of the post-war era and was formally declared a subversive organization by the US Department of Justice in 1947. It struggled on for three more years, but as John Roberts has noted, "the culture had shifted to such an extent that it was impossible for the group to operate freely, even on its own by then highly restricted political terms."[36] While mass market magazines such as *Fortune*, *Look* and *Life* published work by Photo League and FSA photographers during the 1930s and early 1940s, by the end of the decade it had become unpopular to criticize the American way of life. Those who did "were frequently branded as subversives, fellow travellers or Communists"[37] and in this "political and cultural atmosphere, there were very few editors or agencies who would risk sponsoring photographers who wanted to deal with controversial subjects or with 'what had gone wrong' with America."[38] The National Film Board of Canada was the exception to this scenario. Although Grierson was forced to leave in 1945, the NFB has continued to produce "social documentary" films up to the present day.

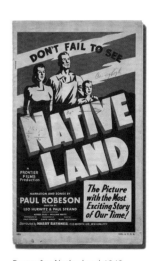

Poster for *Native Land*, 1942 directed by Leo Hurwitz and Paul Strand

Furthermore, the emphasis on "propaganda" that had been so central to the work of the British and American documentary projects since the late 1920s was diametrically opposed to an emergent American avant-garde that, as the Popular Front and its associated realism lost all credibility through its association with Stalinism, was focused on the development of an abstract art that could not easily be co-opted as propaganda. As articulated by George L.K. Morris, an art critic, member of the American Abstract Artists and financial supporter of the journal *Partisan Review*, the American Abstract Artists shared the widely held conviction in democracy and cultural progress professed by artists aligned with the Popular Front, but broke with the pro-Popular Front American Artists' Congress in that:

15

...they also believe that the aesthetic impulse cannot become a tool for concrete political or philosophic dissemination—at this stage of our cultural metamorphosis at least. The present decade may have publicized at last the crevices in the old social order. The [American Artists' Congress] illustrates the crevices. The abstractionists, on the other hand, attempt to reorder their plastic instincts; they attack the established conceptions of art itself.[39]

Aaron Siskind
Neat, we've been asking the landlord to paint for two years from *The Harlem Document*, 1937–39

The ascension of Abstract Expressionism in the late 1940s and 50s seemed to confirm Morris' position and that of other critics, including Clement Greenberg, who were associated with the *Partisan Review*, leaving documentary photography and film (and photography in general) in a tenuous position within the framework of the gallery/museum world. Although it shifted the terms, the rise of conceptual art, with its interrogation of the institutional frameworks and ontological aesthetics within which art had come to operate in the post-war era, left documentary work and the truth claims to which it was seen to be attached in an equally marginal position. This skepticism was extended in the late twentieth century with the application of critical theory and linguistic analysis to the ways in which meaning is constructed in and through photographic images, and the development of critiques that proposed that, in a world pervaded with spectacular images, the task of the artist should be to deconstruct the systems through which images flow and provide critical considerations of the ways images act upon us.

Central to these critiques is the way that meaning in documentary images is unstable, as well as the extent to which the context in which they are employed can both mask and reiterate the structures of power that have produced the subject matter they depict. As Martha Rosler put it in her 1981 essay "In, around, and afterthoughts (on documentary photography)": "Documentary, as we know it, carries (old) information about a group of powerless people to another group addressed as socially powerful," a configuration in which the photographer is often positioned as the only agent capable of action, while those being depicted often appear as pathetic, helpless and incapable of doing anything for themselves.[40]

This has been particularly problematic in the art world, where, as Rosler points out, "a documentary image has two moments: (1) the 'immediate', instrumental one, in which an image is caught or created out of the stream of the present and held up as testimony...arguing for or against a social practice and its ideological-theoretical supports, and (2) the conventional 'aesthetic-historical' moment, less definable in its boundaries, in which the viewer's argumentativeness cedes to the orgasmic pleasure afforded by the aesthetic 'rightness'...of the image." Describing a paradigm that precisely fits the repositioning of Siskind's *Harlem* photographs outlined previously, Rosler goes on to note that:

> This second moment is ahistorical in its refusal of specific historical meaning yet 'history minded' in its very awareness of the pastness of the time in which the image was made. This covert appreciation of images is dangerous insofar as it accepts not a dialectical relation between political and formal meaning, not their interpenetration, but a hazier, more reified relation, one in which topicality drops away as epochs fade, and the aesthetic aspect is, if anything, enhanced by the loss of specific reference.[41]

For Rosler, the central problem with maintaining the configuration of formal and political meaning in the experience of viewing a documentary photograph is:

> the mutability of ideas of aesthetic rightness...the fact that historical interests, not transcendental verities, govern whether any particular form is seen as adequately revealing its meaning—and you cannot second-guess history...It seems clear that those who...identify a powerfully conveyed meaning with a primary sensuousness are pushing against the gigantic ideological weight of classical beauty, which presses on us the understanding that in the search for transcendental form, the world is merely the stepping-off point into aesthetic eternality.[42]

Nevertheless, the desire for an authentic representation of the real is deeply ingrained in contemporary culture and despite (or more likely because of) the problematic histories that are crudely outlined here, documentary practices have been one of the most important areas of activity in the art field over the past twenty-five years. Rather than a limitation, the vagueness of the term "documentary" made a contribution to its reinvigoration. As Olivier Lugon has put it:

> ...what might seem to be the documentary project's fundamental weakness—the nebulous definition, assorted approaches—has undoubtedly been the chief factor influencing its viability: a propensity to keep on discussing its methods and goals, reinventing ways of providing a faithful, correct description of reality...This is the infinitely productive paradox of the documentary: when its basic principle—"to show things as they are"—seemed to restrict the genre to a repetitive duplication of reality and deprive it of any opportunity for development, this very simply formulated principle actually gave rise to a constant exploration of new procedures and forms.[43]

The innovative forms Lugon refers to extend from multi-screen projections, satirical mockumentaries, research archive/installations and spatial interventions, as well as more straightforward presentations of photography, film and video, while the procedures that produce these forms range from the reconstruction of historical moments, the recontextualization of news footage and the use of recombinant editing techniques, to the production of narratives that deliberately acknowledge documentary's internal contradictions. Of equal importance are the works of artists who draw upon a documentary impulse as one of a broader set of strategies that add complexity to their practice. While what has come to be referred to as the "documentary turn" in contemporary art encompasses an extraordinary range of sometimes conflicting subject positions, the activities it comprises share common ground in their embrace of the fundamental tension between the desire to let that which is depicted override conventional

17

modes of authorship and the aspiration to locate the work in the realm of the aesthetic. Furthermore, while recent documentary work is inclined to undercut an absolute claim to truth though the implication of uncertainty and/or imperfection, it also rejects the claim sometimes associated with Postmodernism that the material world has entirely disappeared into a terrain of images or that the real can be entirely accounted for by representation.

While the artistic practices represented in *Residue: The Persistence of the Real* respond to the debates concerning documentary in very different ways, they find common ground in the desire for a connection with social realities and the rejection of disinterestedness as a necessary condition of art. Through diverse approaches, these bodies of work propose that while the real is always mediated by representation, and moves through a complex and ever-changing system of symbolic and material economies, it is not necessarily effaced in the process. Perhaps, as David Campany has argued in his discussion of the interplay between the aesthetic and documentary operations in Atget's photographs, there is "a space between document and artwork...a space that allowed him to satisfy the demands of others and the demands of his own calling, without ever having to define either in the last instance."[44] And, perhaps, within this space the real is like a substance that clings to the surface of representation—like a scum or a residue that can't be completely wiped off.

ENDNOTES

1 Olivier Lugon, "'Documentary': Authority and Ambiguities," *The Green Room: Reconsidering the Documentary and Contemporary Art #1*, eds. Maria Lind and Hito Steyerl (Berlin: Sternberg Press; Annandale-On-Hudson: Center for Curatorial Studies and Hessel Museum of Art, Bard College, 2008), 29.

2 Ibid.

3 John Grierson, "First Principles of Documentary," *Nonfiction Film Theory and Criticism*, ed. Richard Meran Barsam (New York: Dutton, 1976), 22.

4 Grierson, 21.

5 Ibid.

6 Paul Swann, *The British Documentary Film Movement, 1926–1946* (Cambridge: Cambridge University Press, 1989), 2.

7 Sir Stephen Tallents, cited in Swann, 2.

8 Zoë Druick, "At the Margins of Cinema History: Mobile Cinema in the British Empire," *Public*, no. 40 (2009): http://public.journals.yorku.ca/index.php/public/article/view/31980.

9 Ibid.

10 Bill Nichols, "Documentary Film and the Modernist Avant-Garde," *Critical Inquiry*, vol. 27, no. 4 (Summer 2001), 582.

11 Nichols, 592.

12 Grierson, 22–3.

13 Grierson, cited in Nichols, 601.

14 Jack C. Ellis, "Drifters," http://www.filmreference.com/Films-Dr-Ex/Drifters.html#ixzz3UmCHVnVw.

15 Beaumont Newhall, "Documentary Approach to Photography," *Parnassus*, vol. 10, no. 3 (March 1938): 4.

16 Lugon seems to have had Newhall's essay in mind when he criticizes this lineage, arguing that it "is as arbitrary as it is illogical. What, basically, is the connection between the conservative approach of Atget (photographs to keep old things alive), the desire for social reform of Hine (photographs to bring about change), and the more literary pursuits of Evans?" See Lugon, 30–1.

17 Newhall, 5.

18 Ibid.

19 Ibid.

20 Christopher Phillips, "The Judgement Seat of Photography," *The Contest of Meaning: Critical Histories of Photography*, ed. Richard Bolton (Cambridge and London: The MIT Press, 1989), 18.

21 Newhall, cited in Phillips, 21.

22 Adams, cited in Roy Stryker and Nancy Wood, "The FSA Collection of Photographs," *In This Proud Land: America 1935–1943 as Seen in the FSA Photographs* (Greenwich, Connecticut: New York Graphic Society Ltd., 1973), 7.

23 Newhall, 5.

24 Newhall, 6.

25 Samuel Brody, cited in "History: Worker's Film and Photo League," http://xroads.virginia.edu/~ma01/huffman/frontier/history.html.

26 Leo Hurwitz, "The Revolutionary Film—The Next Step," http://xroads.virginia.edu/~ma01/huffman/frontier/hurwitzreview.html.

27 Ralph Steiner and Hurwitz, "A New Approach to Film Making," *New Theatre* (September 1935): 22–3.

28 William Alexander, "Frontier Films, 1936–1941: The Aesthetics of Impact," *Cinema Journal*, vol. 15, no. 1 (Autumn 1975): 17.

29 The review is available online at: http://edinburghfilmguild.org.uk/programme_notes/native_land.pdf.

30 Anne Tucker, cited in John Roberts, *The Art of Interruption: Realism, Photography and the Everyday* (Manchester and New York: Manchester University Press, 1998), 90.

31 See Roberts, 90–1.

32 According to Paula J. Massood, Carter was actually a journalist named Martin Smith. See Massood, *Making a Promised Land: Harlem in Twentieth-Century Photography and Film* (New Brunswick: Rutgers University Press, 2013), 95.

33 See Roberts, 92.

34 Joseph B. Entin, *Sensational Modernism: Experimental Fiction and Photography in Thirties America* (Chapel Hill: University of North Carolina Press, 2007), 116.

35 Ibid.

36 Roberts, 96.

37 James Guimond, *American Photography and the American Dream* (Chapel Hill: The University of North Carolina Press, 1991), 141.

38 Guimond, 142.

39 George L.K. Morris, cited in Serge Guilbaut, *How New York Stole the Idea of Modern Art* (Chicago: University of Chicago Press, 1983), 37.

40 Martha Rosler, "In, around, and afterthoughts (on documentary photography)," *The Contest of Meaning*, 306.

41 Rosler, 317.

42 Ibid.

43 Lugon, 31–2.

44 David Campany, "Eugène Atget's Intelligent Documents," http://davidcampany.com/atget-photographe-de-paris.

Robert Burley
Executive Entrance, Building 7, Kodak Canada,
Toronto, 2005

20

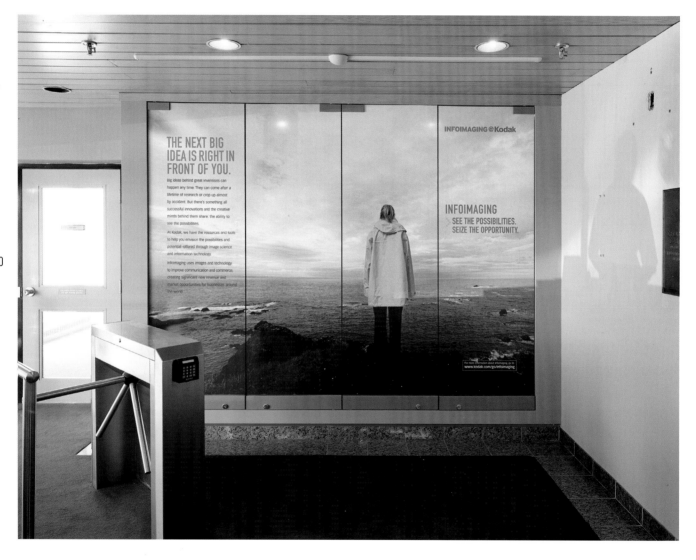

ROBERT BURLEY
THE DISAPPEARANCE OF DARKNESS

An accomplished photographer of architecture, Robert Burley situates his work within a tradition that ranges from Eugène Atget's attempt to produce a comprehensive record of the streets and architecture of Paris before they were effaced by modernization in the late nineteenth and early twentieth centuries, and Bernd and Hilla Becher's vast typological survey of industrial architecture undertaken in the latter half of the twentieth century. Burley's work addresses spaces in which the histories and connective mechanisms of the urban environment are visible. His work is usually project based, involving an extended engagement with a particular site or subject matter, and is often conceived as a book as well as a body of photographs for exhibition.

For *Viewing Olmsted* (1989–95), for example, a project commissioned by the Canadian Centre for Architecture in Montreal in 1989, Burley—along with photographers Lee Friedlander and Geoffrey James—surveyed the landscape architecture of Frederick Law Olmsted over the course of six years. The commission was realized as an exhibition, a book and an archive of more than 900 photographs. Compared in scope to public photographic commissions such as the nineteenth-century Missions Héliographique, *Viewing Olmsted* examined the landscape architect's parks as embodiments of civic value and measured the extent to which the currency of this rhetoric remains viable.

Burley began working on *The Disappearance of Darkness* in 2005, when he learned of the impending closure of Kodak Heights—Kodak Canada's office and manufacturing complex located on the outskirts of Toronto, which had been in continuous production since the First World War. Not long after he began to photograph the facility, Eastman Kodak announced that it would demolish a large part of its manufacturing complex in Rochester, New York. Over the following six years Burley expanded his project to include the suddenly redundant facilities in Rochester, as well as those of the Kodak-Pathé plant in Chalon-sur-Saône, France; Agfa-Gevaert in Mortsel, Belgium; Polaroid in Waltham, Massachusetts; Polaroid/Impossible Project in Enschede, the Netherlands; and Ilford in Mobberley, England, along with the small-scale portrait studios and film-processing labs that depended on analogue materials.

In spite of the ever-increasing ubiquity of photographs in everyday life, the scale of infrastructure associated with the photography industry has not had the same presence in the public imagination as that of automobile manufacturing or oil exploration. For the most part, interaction with entities like Kodak has taken place over the photo counter of a neighbourhood drugstore. As a result, the images that make up *The Disappearance of Darkness* might initially evoke a level of surprise at the scale of the industry, implied in the size of these largely windowless structures and the specialized activities—coating, cutting, warehousing—to which they were dedicated. This is reiterated in the strangely futuristic character of the structure that houses Agfa-Gevaert's film-coating operations and its modular storage facility, which seem more like the epitome of industrial efficiency than markers of technological obsolescence. On the other hand, the 1970s era clock and only slightly more recent carpet in *Empty Offices, Polaroid, Enschede, The Netherlands* (2010) undercut the sense of contemporaneity that might be associated with the production facilities.

The interiors depicted in *The Disappearance of Darkness* are depopulated, though the presence of former employees is indicated by instructions to "call and watch out" when moving through darkened spaces and the fading identification badges systematically arranged to indicate which members of the staff that

once worked at Polaroid's facility in Enschede were on vacation or ill when the facility closed. The pathos of the battered filing cabinets, worn carpet and kitschy sunset photograph in the image of an office in Kodak Canada's Building 7 is heightened in comparison to the somewhat higher-end materials used in the executive entrance of the same building and the now-ironic humour played out in the tawdry slogan exhorting Kodak's management to "see the possibilities, seize the opportunity."

It's reasonable to assume that former Kodak employees comprise a significant part of the crowd that witnessed the implosions of Buildings 65 and 69 in Kodak Park in 2007. A large Kodak logo appears on the t-shirt worn by a woman in the centre-right portion of the image, and the near-retirement age of the majority of the spectators also supports this interpretation. Oddly enough, Burley was one of the few who used film to record the event, as most of the spectators used digital devices—either digital cameras or cell phones. While it might be too much of a stretch to equate Burley's position with that of Atget's "man out of time"—who used outdated glass plates to record a version of Paris on the verge of disappearance—these images do speak to the contradictions of modernity that have become associated with Atget's photographs through the work of cultural critics like Walter Benjamin and David Campany, albeit from a position at the end of an era of modernity that has been constituted through the logic of mechanical operations and industrial production.

Through their scale, transfer of scientific knowledge into technology and vertical integration of products and services, entities like Kodak were a paradigm of the rationalized modes of production and widely dispersed forms of distribution that characterized the experience of modernity from the late nineteenth to the late twentieth centuries. Overlapping with technological advances in transportation and communications, the unceasing circulation of mimetically accurate images of objects, people and distant places had the effect of speeding up time and diminishing distance. Furthermore, as a child of modern progress that was condemned "to look backward, to document 'what is' and present it as 'what was'... photography could leave behind facts but no interpretation of them. It could acknowledge the existence of particular things but could not guarantee a *particular* knowledge of them. Detective work would be needed [to make images] meaningful."[1]

Though analogue photography and the means through which it is distributed once seemed rapid, the rise of digital technologies and the ability to almost instantaneously circulate an image through a network of cell phones, tablets and computers have caused conventional photography to be re-characterized as slow and static. In their portrayal of the industry's demise in the early years of the twenty-first century, Burley's photographs question the extent to which the absence of bodies in the interiors of these abandoned structures corresponds with the capacity of digital imagery and information to circulate without taking on physical form and, by extension, how this might shape lived experience in an era in which the logic that defined modernity over the past hundred years is dispersed and reconfigured.

22

ENDNOTES

1 David Campany, "Eugéne Atget's Intelligent Documents," http://davidcampany.com/atget-photographe-de-paris.

Robert Burley
Administrative Area, Building 7, Kodak Canada,
Toronto, 2006

23

Robert Burley
Darkroom, Building 3, Kodak Canada,
Toronto, 2005

24

Robert Burley
Empty Offices, Polaroid, Enschede,
The Netherlands, 2010

Robert Burley
Executive Office, Building 7, Kodak Canada,
Toronto, 2006

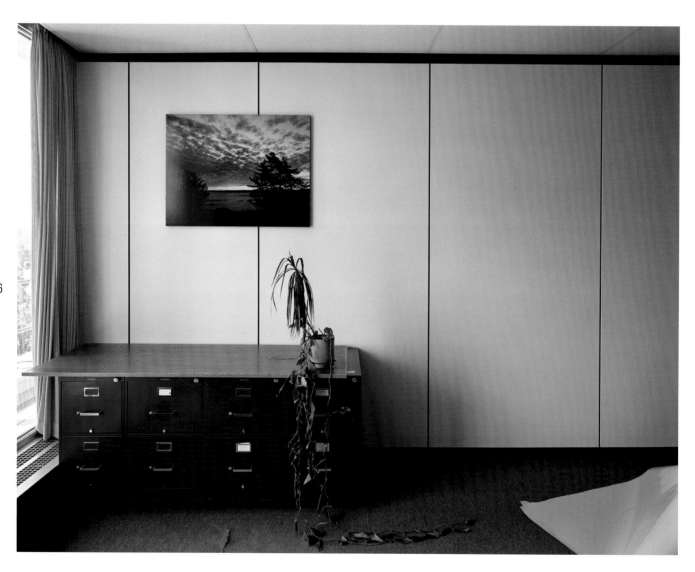

Robert Burley
Film Coating Facility, Agfa-Gevaert, Mortsel,
Belgium (#1), 2007

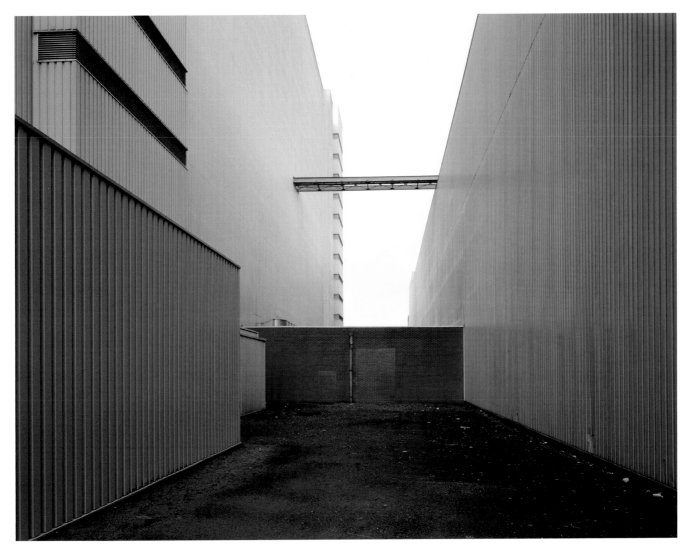

27

Robert Burley
Employee Identification Board, Polaroid, Enschede,
The Netherlands, 2010

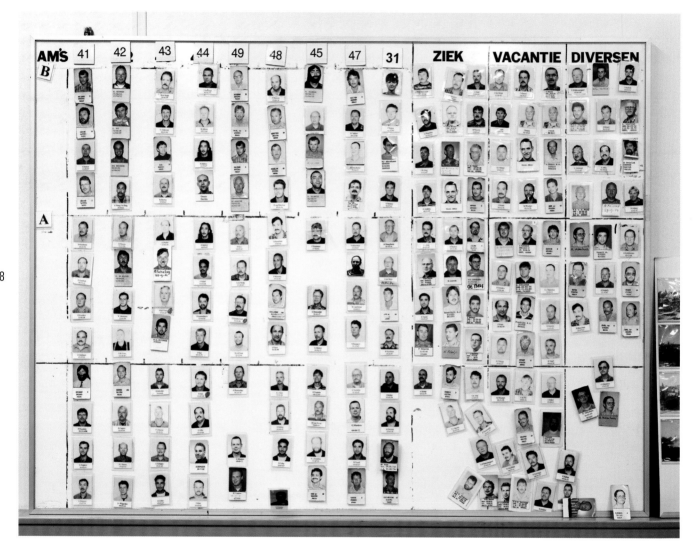

Robert Burley
Film Warehouse, Agfa-Gevaert, Mortsel,
Belgium, 2007

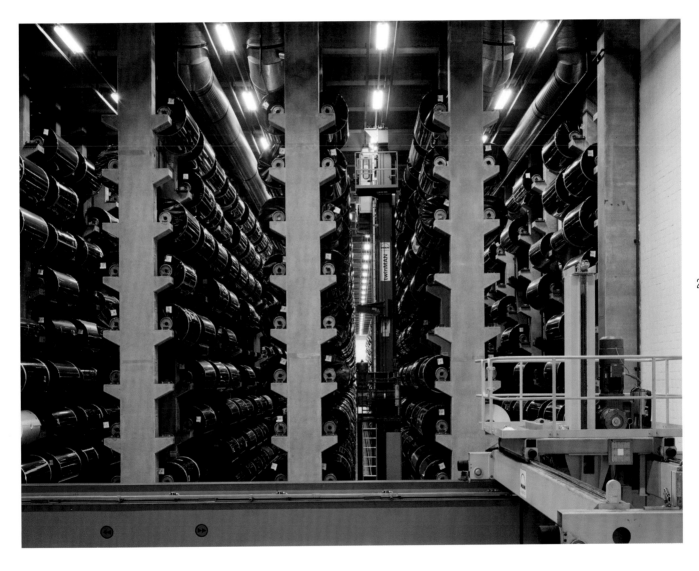

Robert Burley
Faded Proof, 2005–12

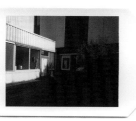 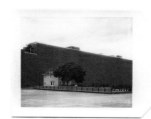 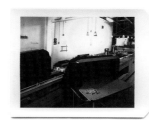

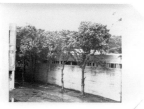 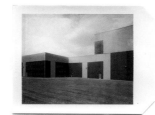 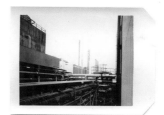 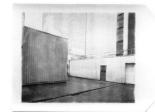

30

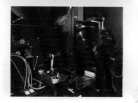 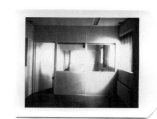

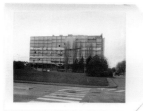 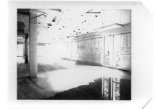

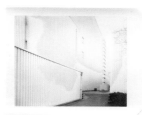 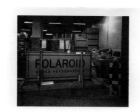

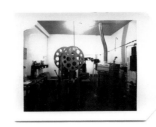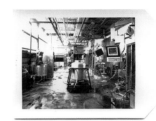
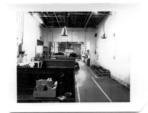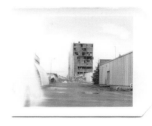
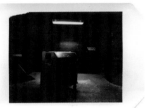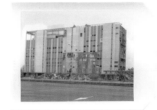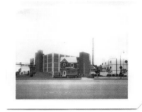
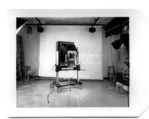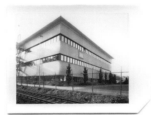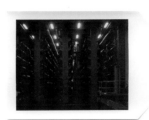
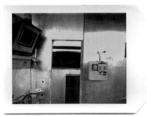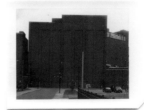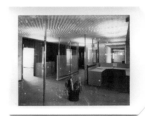
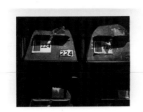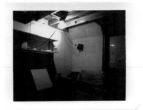

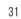

ROBERT BURLEY

Robert Burley

Awaiting the Implosions of Buildings 65 and 69,
Kodak Park, Rochester, New York, 2007

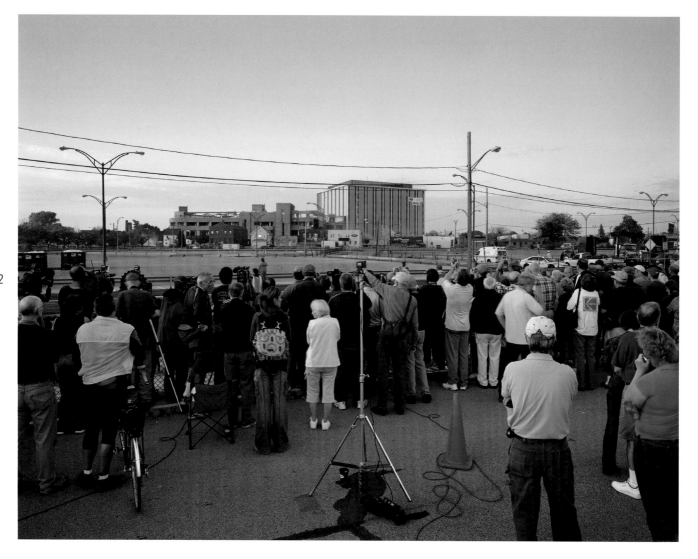

Robert Burley

Implosions of Buildings 65 and 69, Kodak Park,
Rochester, New York (#1), 2007

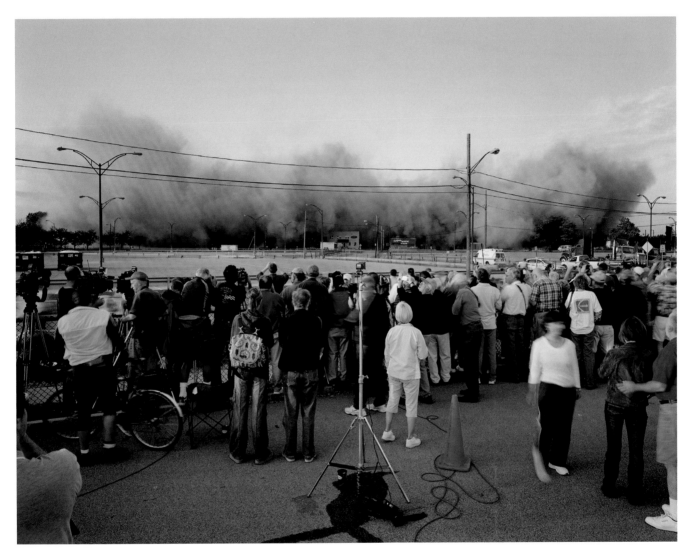

33

Robert Burley
Implosions of Buildings 65 and 69, Kodak Park,
Rochester, New York (#2), 2007

34

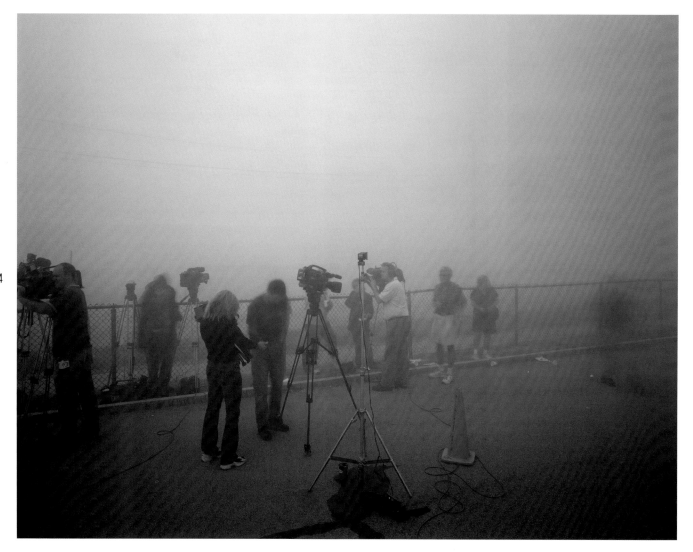

Robert Burley

After the Implosions of Buildings 65 and 69,
Kodak Park, Rochester, New York, 2007

Stan Douglas
Luanda-Kinshasa, 2013 (still)

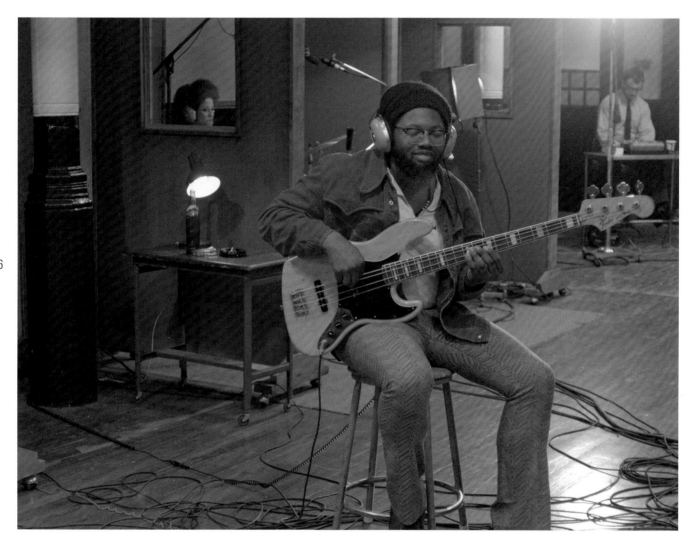

STAN DOUGLAS
LUANDA-KINSHASA

Music as a manifestation of cultural tensions and possibilities has always played a prominent role in Stan Douglas' practice. Over the past thirty years his work has embraced an array of musical idioms that include Robert Johnson's delta blues, Arnold Schoenberg's soundtracks for hypothetical films, Albert Ayler's free jazz and Goblin's Italian prog rock. Deployed within rigorously thought out technical structures, Douglas uses music to explore brief moments when the revolutionary possibilities of an avant-garde aligned with popular culture, and the subsequent dispersal of those possibilities within Modernism's failed promises.

Luanda-Kinshasa (2013) extends this facet of Douglas' work through its depiction of a hypothetical jazz-fusion recording session in Columbia Records' 30th Street Studio in Manhattan. Known as "The Church," the studio was a legendary component of the New York music scene from its opening in 1948 until its closure in 1981. An extraordinary range of ground-breaking albums were recorded there, including Glenn Gould's *Bach: The Goldberg Variations* (1955), Miles Davis' *Kind of Blue* (1959), Aretha Franklin's *Aretha with the Ray Bryant Combo* (1961), Bob Dylan's *Highway 61 Revisited* (1965) and Pink Floyd's *The Wall* (1979). The studio played a crucial role in the development of American jazz-fusion during the late 1960s and early 70s, which pushed traditional boundaries by combining rhythms from funk and R&B with the electronic amplification of rock and the complex time signatures of African and Indian music in an attempt to reach a younger audience.

Recorded at the 30th Street Studio in 1969, Miles Davis' *In a Silent Way* is among the earliest jazz-fusion recordings. In addition to its embrace of electric instrumentation, the album was the first of the artist's recordings to use the studio itself as a musical instrument, as new recording technology allowed him and producer Teo Macero to create compositional structures through the reordering and repetition of passages in the post-production process. It was also the first time Davis worked with John McLaughlin, whose searing rock-influenced guitar solos would feature prominently in his subsequent albums, including *Bitches Brew* (1970) and *A Tribute to Jack Johnson* (1971). Davis added the tabla and sitar to the instrumentation of *On the Corner* (1972), while expanding the use of tape loops and echo effects initiated with *In a Silent Way*. The reception of these experiments varied drastically; *Bitches Brew* sold more than half a million copies and was Davis' first gold record, while *On the Corner* was vilified by jazz critics and had the lowest sales of any his recordings.

As with all of Douglas' work, *Luanda-Kinshasa* is a product of extensive research into a specific historical episode. Every detail of the studio's interior—the clothing and hair styles of the cast, the racial makeup of the band and recording crew, the electrical fans that cool the room—evokes New York's mid-1970s jazz-fusion scene. This precision allows the viewer to quickly recognize the era in which the film is set, while at the same time emphasizing that every aspect of the work is loaded with meaning. This extends to the work's title, which evokes the growing interaction between American and African music during the mid-1970s.

Luanda-Kinshasa's camera work is modelled on the cinematography of Jean-Luc Godard's 1968 film *Sympathy for the Devil*.[1] A little more than half of Godard's film is made up of "documentary" footage of the Rolling Stones as they develop and record *Sympathy for the Devil* in London's Olympic Sound Studios in

June 1968. The Stones footage is interwoven with scenes of a group of Black Panthers in a junkyard who toss rifles to each other, read texts on the theft of black music by white musicians and eventually shoot some white women. The film also incorporates scenes from a bookstore that sells comic books, porn and Nazi pamphlets, in which customers slap the faces of Maoist hostages and read passages from *Mein Kampf*. Produced in the aftermath of the May 1968 student uprising in Paris, Godard intended the film as an anarchic fusion of "art, power and revolution." However, it was poorly received in France and Godard missed his opportunity to "subvert, ruin and destroy all civilised values."[2]

Godard's depiction of the recording session is a series of long takes in which the camera tracks, pans and tilts as it moves through the studio, often turning away from the musicians to focus on technicians, girlfriends and peripheral details. *Luanda-Kinshasa* closely emulates this "documentary" footage; however, as Michael Vass has pointed out, in Douglas' work the camera is "more conventionally integrated into the scene [Douglas is] depicting; it glides smoothly from musician to musician foregrounding the dynamic between the players." As a result, for Godard "the dominant mode is cacophony, whereas for Douglas it is coherence."[3] This logic persists even when the viewer becomes aware of *Luanda-Kinshasa*'s recombinant structure, in which scenes are replayed in different permutations over the video's six-hour duration.

The ethnic makeup of the ten-member band in *Luanda-Kinshasa* is consistent with those that performed on Miles Davis' recordings of the late 1960s and early 70s, though the inclusion of female drummer Kimberly Thompson is a departure from Davis' all-male lineups. Their vivid approximation of 70s jazz-fusion is a hypnotic mashup in which droning harmonies of wah-wah-pedalled electric guitars, Indian chimes, Fender Rhodes keyboards and soprano saxophone at times soar above funk-rhythmed bass lines and a thumping percussion section (oddly enough, given the close relationship to the music of Miles Davis, there is no trumpet). The intricately engineered audio track accentuates the instrument the camera is focused on, giving the sound an immediate presence that tends to override an understanding that the session is an assembly of repeating fragments.

There is a definite utopian thread running through Douglas' depiction of this culturally diverse configuration in which there is no dominant order, recalling his observation of a similar thread in free jazz: "Maybe those utopias were realized just for a few hours, in a situation where the society was very, very small and briefly capable of working things out."[4] In this respect, *Luanda-Kinshasa*'s reimagining of the past both pays homage to that moment and asks us to consider what its unfulfilled potential offers to the present.

38

ENDNOTES

1 Godard's original title for the film was *One Plus One*. After it flopped commercially, producer Iain Quarrier renamed it *Sympathy for the Devil* and added the complete song—which is otherwise heard only in fragments—at the end of the film. Apparently Godard punched Quarrier in the face when he learned of the revisions.

2 Godard, cited in Josh Jones, *Watch the Rolling Stones Write "Sympathy for the Devil": from Jean-Luc Godard's '68 Film One Plus One*, http://www.openculture.com/2013/11/godard-films-rolling-stones-writing-sympathy-for-the-devil.html.

3 Michael Vass, "Thinking Through Music: Stan Douglas' *Luanda-Kinshasa*," http://canadianart.ca/reviews/2014/02/27/stan-doouglasluands-kinshasa.

4 "Interview: Diana Thater in conversation with *Stan Douglas*," Stan Douglas (London: Phaidon Press, 1998), 22.

Stan Douglas
Luanda-Kinshasa, 2013 (still)

OVERLEAF Stan Douglas
Luanda-Kinshasa, 2013
Installation view at David Zwirner,
New York, 2014

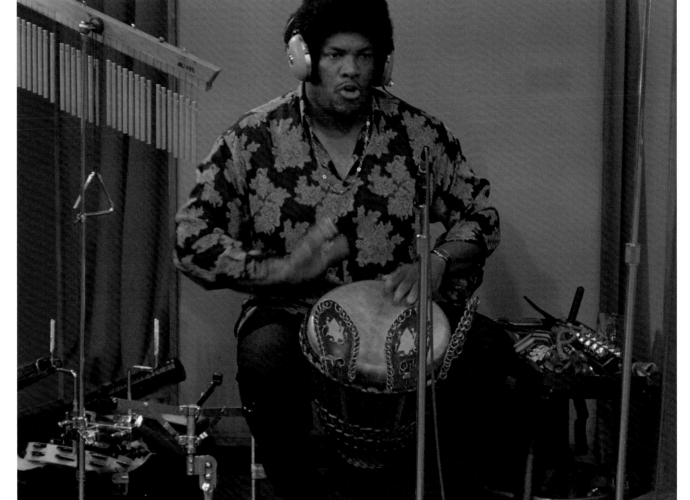

39

STAN DOUGLAS

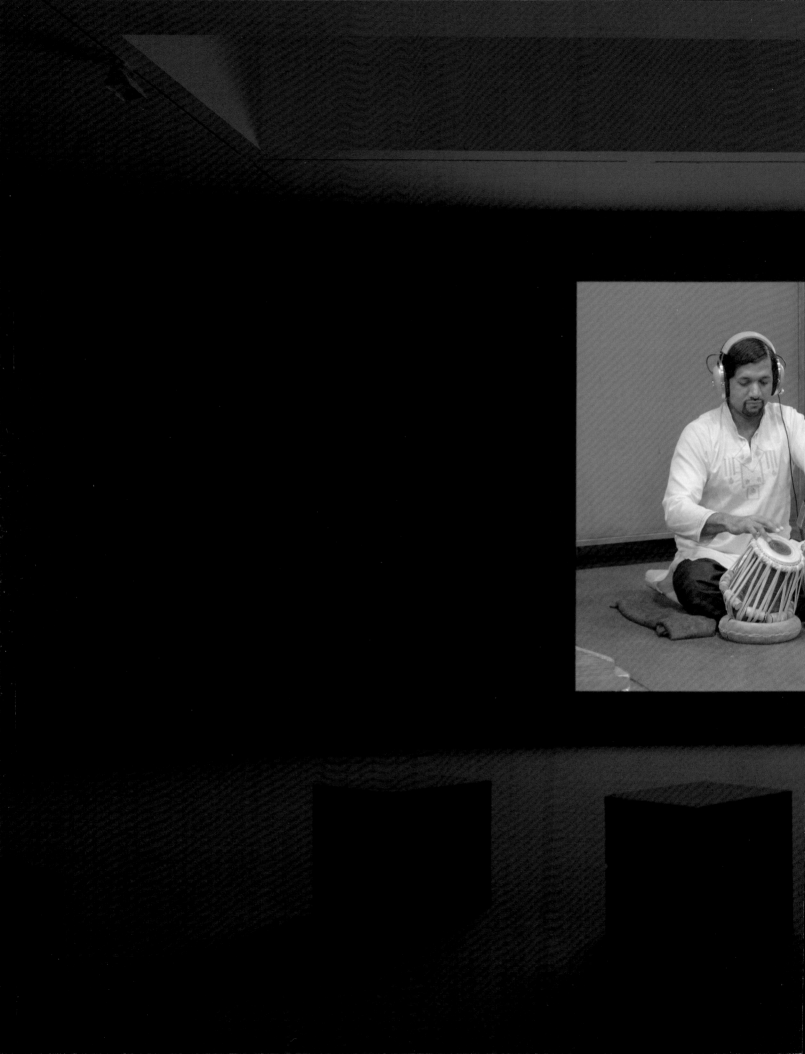

Stan Douglas
Luanda-Kinshasa, 2013 (stills)

42

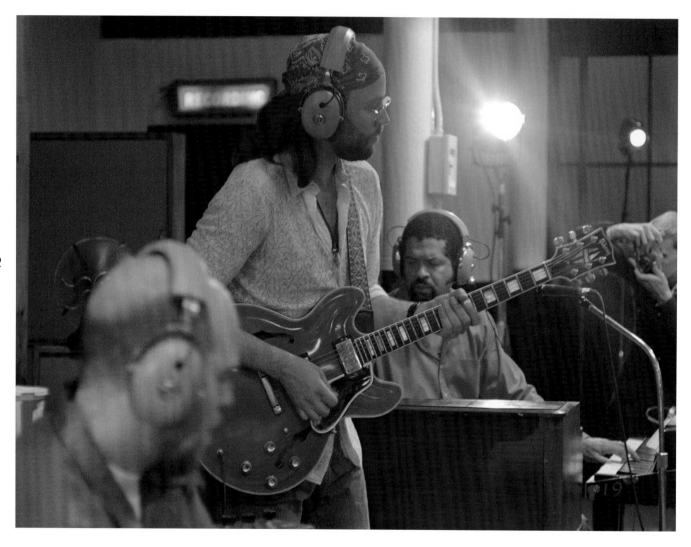

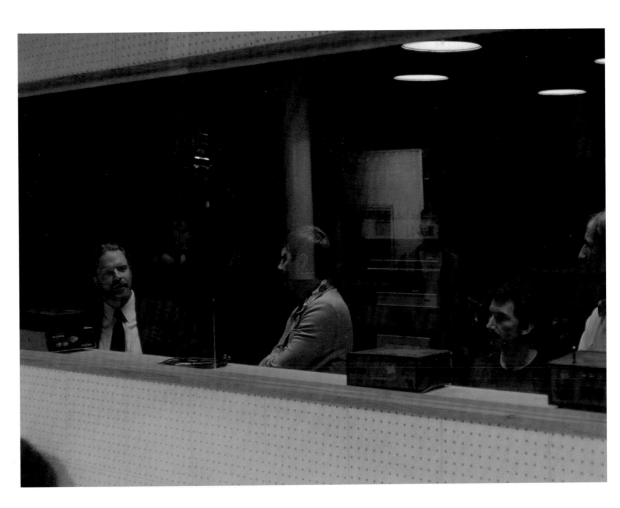

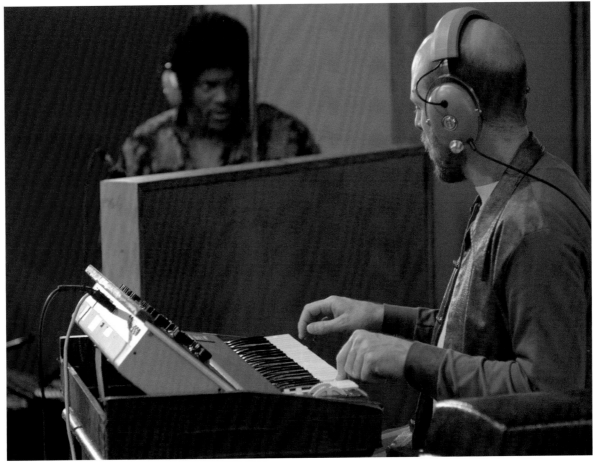

STAN DOUGLAS

Stan Douglas
Luanda-Kinshasa, 2013 (stills)

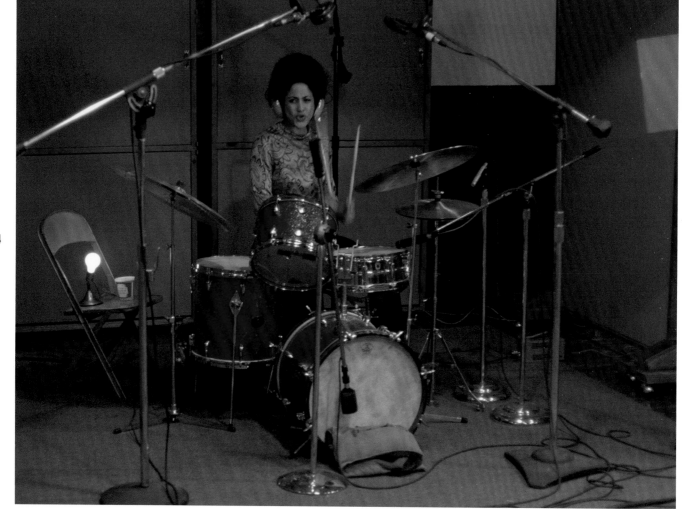

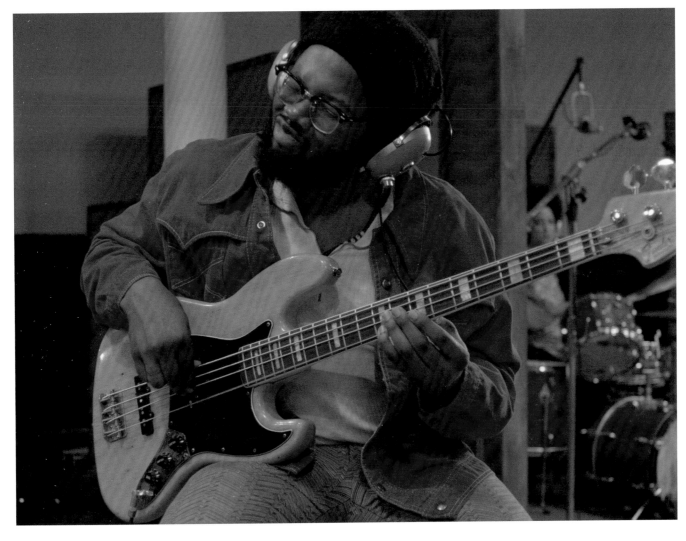

45

Stan Douglas
Luanda-Kinshasa, 2013 (stills)

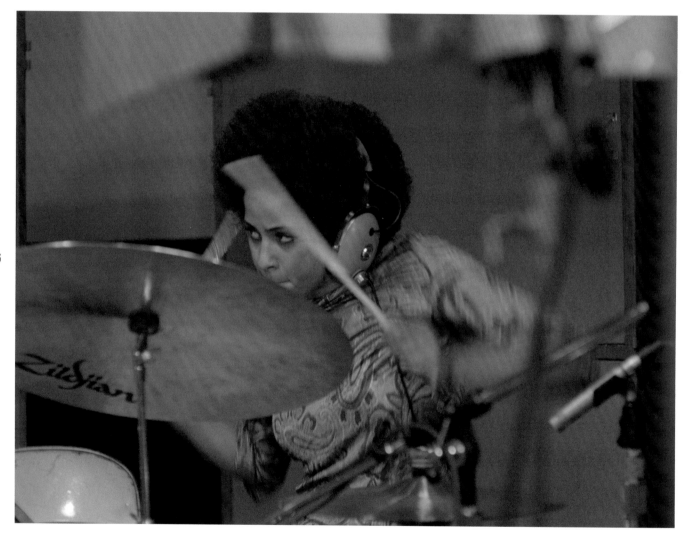

STAN DOUGLAS

Stan Douglas
Luanda-Kinshasa, 2013 (stills)

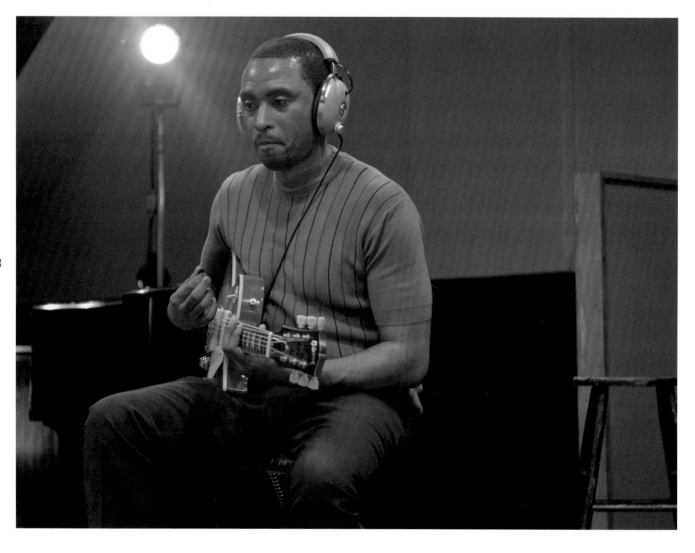

OVERLEAF Stan Douglas
Luanda-Kinshasa, 2013
Installation view at David Zwirner,
New York, 2014

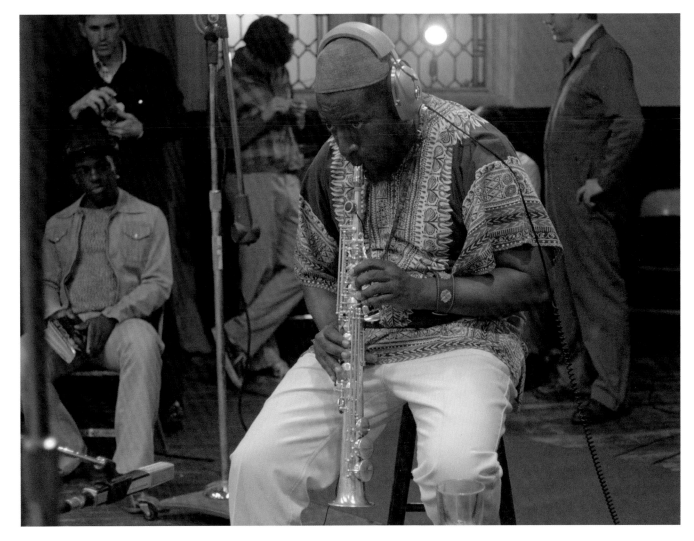

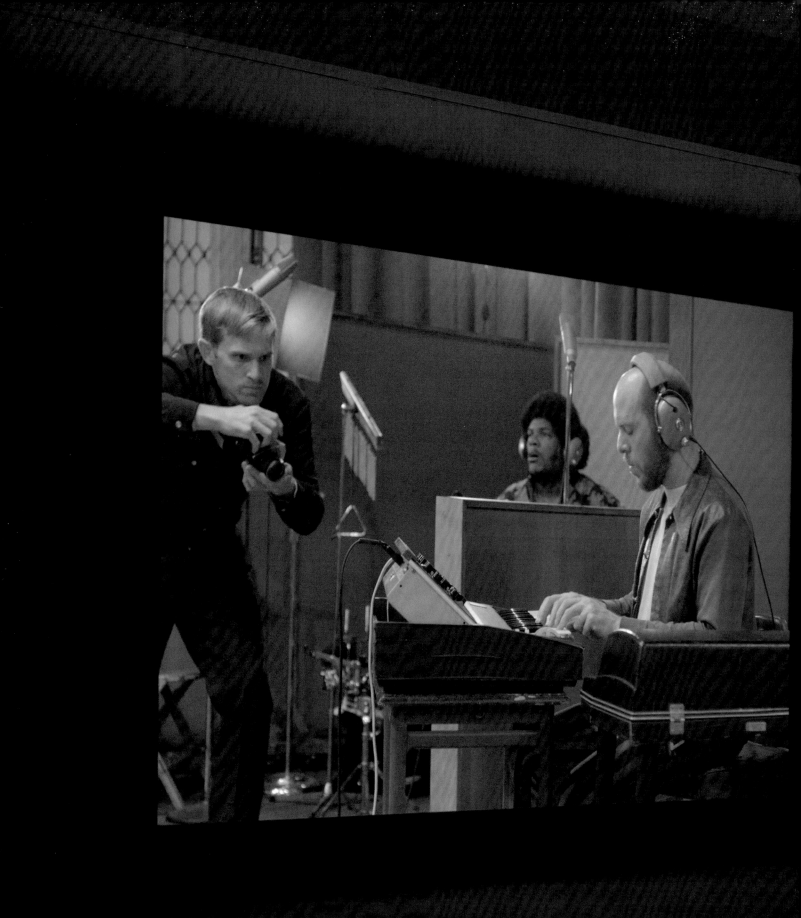

Babak Golkar
The Rise of the Sun (including *The Fall of the Sun*),
2014

BABAK GOLKAR
THE RETURN PROJECT

Babak Golkar's work takes on a variety of forms, including drawing, ceramics, sculpture and photography, in pursuit of his interest in the instability of art, the production of space and the systematic entanglements contemporary culture imposes on everyday lived experience. In a critical consideration of cultural and economic structures, he combines motifs from disparate systems and traditions to invoke their similarities and differences, inviting the viewer to consider the variable relationship between the body and spatial order as a process in which historical and cultural value is inscribed.

Much of Golkar's recent work has emphasized the visceral as a counter to the visual as the dominant order through which we understand the world. *Time to Let Go...* (2014), presented at the Vancouver Art Gallery's public art space Offsite, comprises five unglazed terracotta containers with amphora-like forms that recall Middle Eastern antiquity. The mouth of each vessel mimics the contours of a screaming face, inviting participants to press their own faces to the opening and scream—an opportunity to vent frustration while assuming a position of vulnerability usually reserved for private space. As Golkar put it, the work operates as "a platform for the public to be expressive and experience vulnerability in a public place—and be okay."[1] Physical contact with the rough texture of the terracotta emphasizes the works' specific material character, its handmade origin and the peripheral position of ceramics in the contemporary art world.

The performative role played by the viewer/participant in this work is shifted to the artist in Golkar's *The Return Project* (2014–ongoing). Each work in this project is produced by following a specific procedure: Golkar purchases a cheap domestic object—a candle, an African mask, a small carpet, a framed reproduction of a painting—at a retail chain such as Home Sense or Ikea. Without disturbing the barcode that tracks it in the store's inventory, the object is photographed, substantially altered, re-photographed and returned to the shop it was purchased from, where—presumably—it will be re-shelved and purchased once again. He also asks for a full refund according to each store's return policy. Golkar authenticates each returned item as a work of art by signing and dating the modified object and attaching a note for the new owner. For exhibition purposes, the life-sized before-and-after photographs, along with an article fabricated from "surplus" material removed from the original object, are installed in the gallery space.

To produce *From Africa to the Americas* (including *To Cubism*) (2014), Golkar bought a large wooden mask that was manufactured in Africa for the low-end export market at store in Vancouver. He cut off some of the wood and fashioned it into a small figural sculpture. He then hired a First Nations artist who carves objects for the souvenir market to modify the work so that it resembled a traditional Northwest Coast Native mask, then returned the transformed item to the same store. In this process, manifold layers of association become attached to the small sculpture and the two photographs that depict the transformation of the object—including how creativity is recognized within the networks in which the mask circulates, commentary on the role of exoticism in the domestic environments of middle-class North Americans, the role standardized systems that track commodities play in everyday life and the mechanisms through which monetary value is attached to an object. As the work's title suggests, these questions are linked to the role of "primitivism"—and, by implication, imperialism—in the development of Cubism and Surrealism in the first half of the twentieth century.

In works such as *The Rise of the Sun* (including *The Fall of the Sun*) (2014), in which a small circular carpet was cut in half and one part was returned, or *Fair Trade* (including *Assisted Reconstruction*) (2014), in which the image of a peony was cut from a reproduction of a watercolour painting and placed in a makeshift opium pipe, while the reproduction was replaced with an original watercolour painting of an opium poppy, the question of cultural appropriation is partially displaced by a play between materiality, mimesis and reproduction. What is consistent in all of *The Return Project* works is the indeterminate fate of the end product and the extent to which its status will oscillate between the vulgar and the aesthetic, the mass-produced object and the unique artwork, a fate that depends "entirely on the unknowable intentions, desires, and actions of the...consumer turned collector."[2]

The play between presence and absence that is attached to all photographs is central to Golkar's project. On one level, each pair of photographs has a basic documentary function: it provides evidence that what we see has existed and shows us what the object looked like when it was purchased and when it was returned. The presence of the small "orphaned" object fabricated from surplus material, which occupies the same space as the viewer, emphasizes a sense of absence that attests to the fact that what is pictured in the photographs is not there in front of us. As Roland Barthes put it, "...what the photograph produces to infinity has occurred only once: the Photograph mechanically repeats what could never be repeated existentially..."[3] For Barthes the represented forms refer to something real, but the moment when they were photographed no longer exists—except in the photograph. The image is an absented presence, "which, for Barthes, still holds subjective significance, but not absolute truth. Therefore, Barthes' assessment agrees with the typical association between photography and truth, but in a way that thinks past the extreme binaries of presence=truth and absence=falsity."[4]

If *The Return Project* explicitly acknowledges the codes, institutional structures and patterns of circulation that both constrain meaning and make expression possible, the renunciation of control over the artwork/commodity as it's returned into circulation hangs onto the possibility—however slim—of the presence of something that "is free of language, institutional delineation...and the frame that traps it in a procrustean bed of meanings."[5]

ENDNOTES

1 Babak Golkar, *Time to Let Go...*, http://babakgolkar.ca/time-to-let-go.

2 Abbas Daneshvari, "The Free Play of Signs: Of Flux and Deconstruction," http://babakgolkar.ca/the-free-play-of-signs-of-flux-and-deconstruction.

3 Roland Barthes, *Camera Lucida: Reflections on Photography* (New York: Farrar, Straus and Giroux, 1981), 4.

4 Amanda Bell, "absence/presence," https://lucian.uchicago.edu/blogs/mediatheory/keywords/absence-presence.

5 Daneshvari, "The Free Play of Signs: Of Flux and Deconstruction."

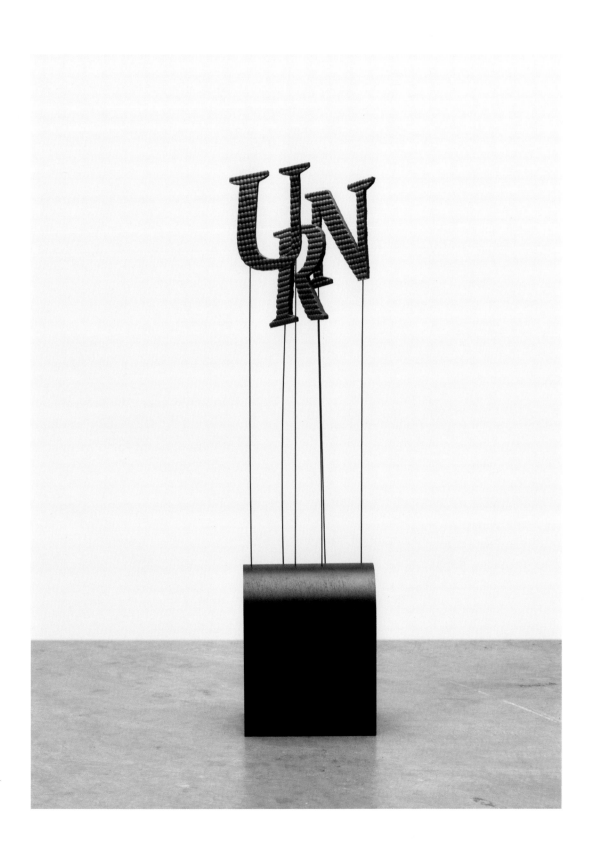

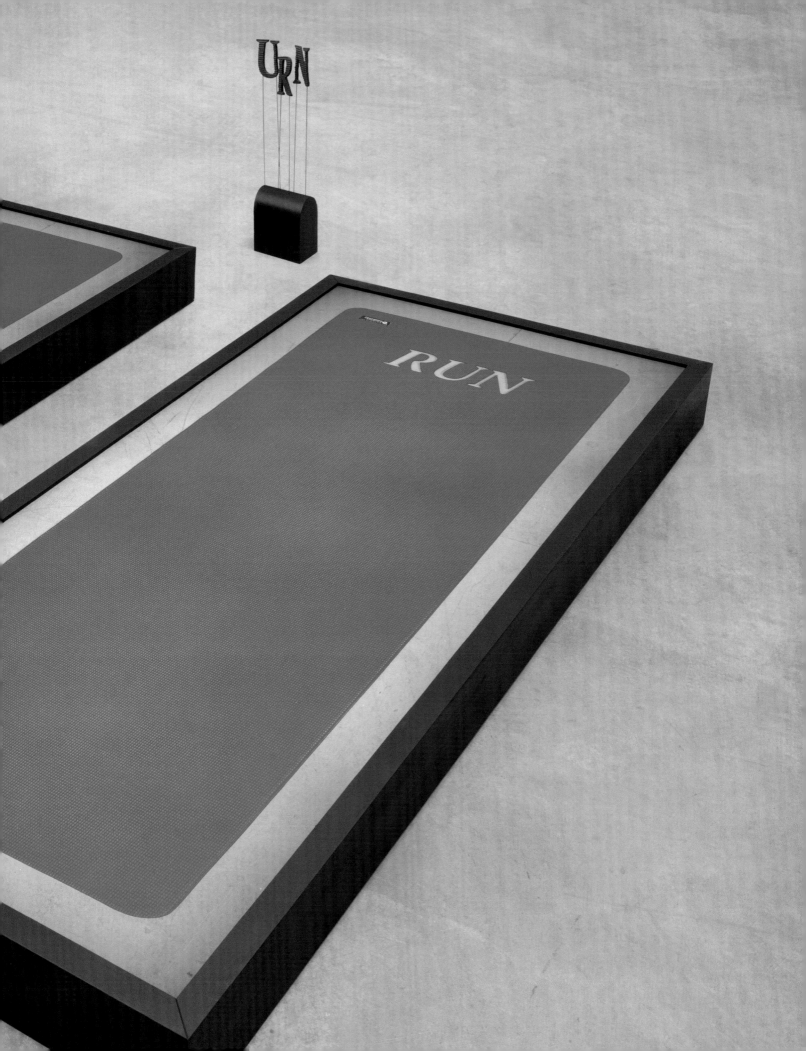

Babak Golkar
From Africa to the Americas
(including *To Cubism*), 2014

58

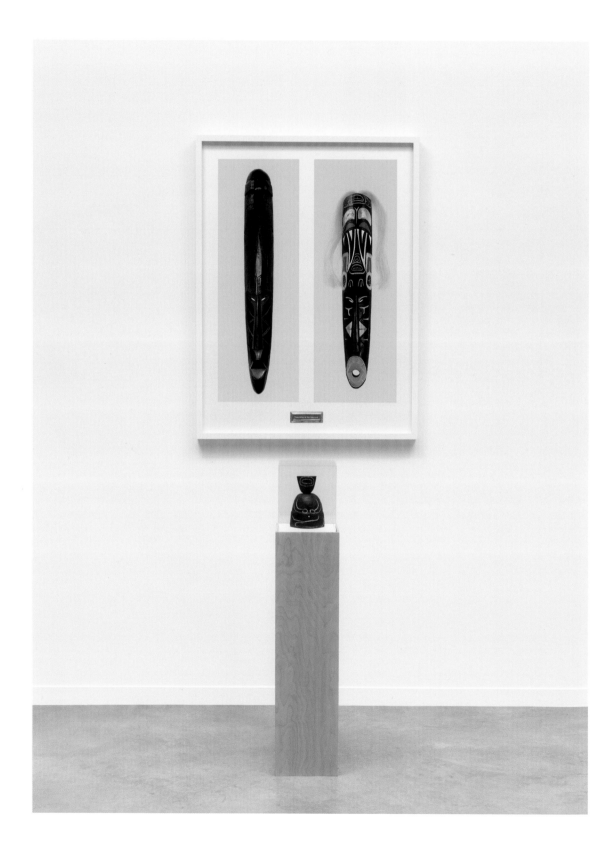

BABAK GOLKAR

Babak Golkar
Constantin, 2014

OPPOSITE Babak Golkar
Brancusi's Alien Fascination
(including *Constantin*), 2014

60

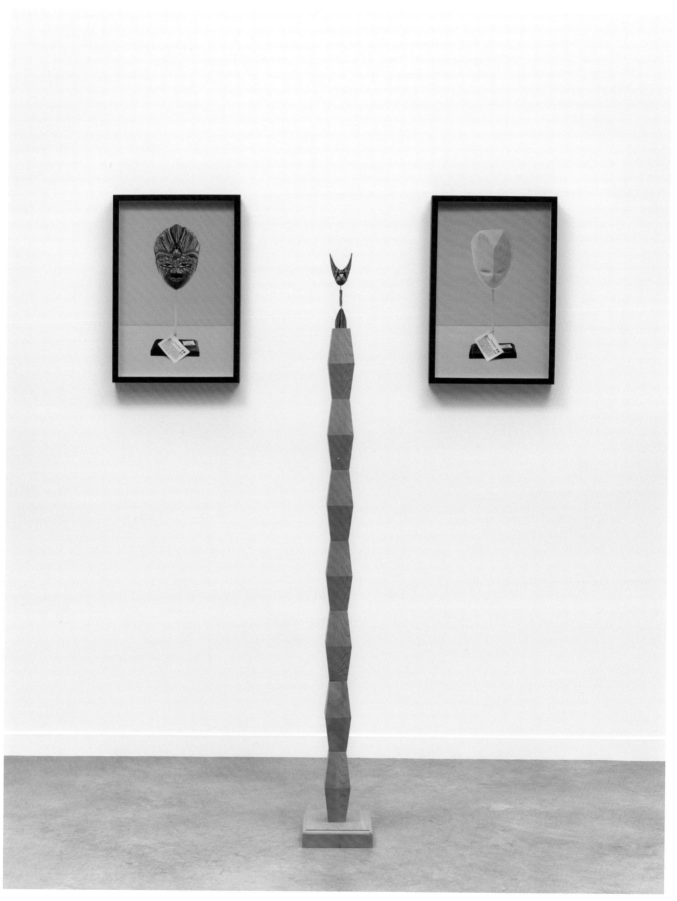

BABAK GOLKAR

Babak Golkar
Fair Trade (including *Assisted Reconstruction*), 2014

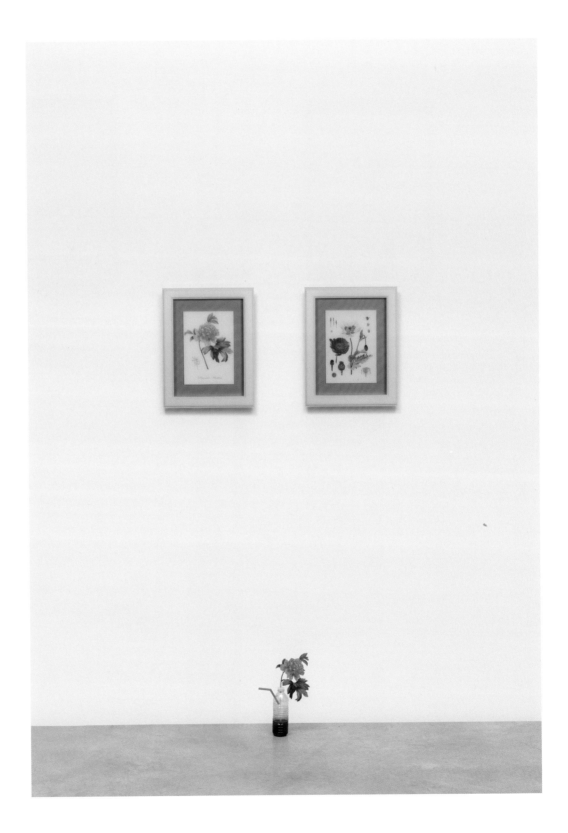

BABAK GOLKAR

Babak Golkar
Never Forgetting Richter, 2014

OPPOSITE Babak Golkar
Tearless (including *Never
Forgetting Richter*), 2014

64

BABAK GOLKAR

Geoffrey James
Improvised screen, Lower E, 2013

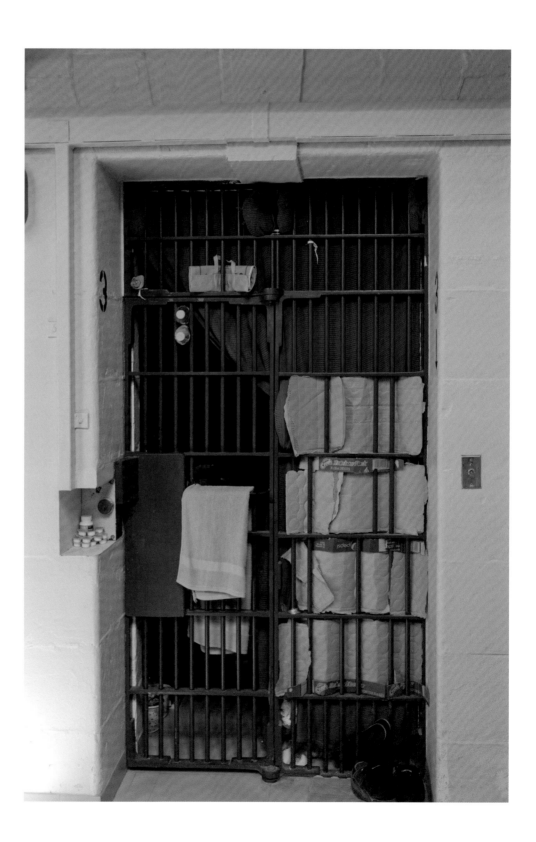

GEOFFREY JAMES
INSIDE KINGSTON PENITENTIARY

Geoffrey James' *Inside Kingston Penitentiary* (2013) depicts Canada's oldest and most infamous prison as it was in the process of being shut down in 2013. Opened in 1835, Kingston Penitentiary occupies a significant place within the local economy and the country's public imagination. It was one of five prisons that, collectively, were the largest employer in the region. Often written about but seldom pictured, it conjures up grim headlines and notorious inmates such as serial killers Paul Bernardo, Roger Caron and Clifford Olson. In spite of this notoriety—or perhaps because of it—life within its walls has remained largely invisible over the past 178 years. As James points out, even the guards were not allowed to take cell phones or cameras into the penitentiary: "prisons are secret places" and "the least visible element of the criminal justice system."[1] This body of work looks at the prison's interior spaces and the traces left behind by inmates who once occupied them as a means to consider the workings of the penal system at large.

Over the past three decades James has examined the human-altered landscape and the built environment as repositories of social value. He became widely known in the early 1980s for his meticulously printed black and white panoramas of seventeenth- and eighteenth-century gardens in Italy and France, as well as his minutely detailed images that trace the imprint of the Roman Empire on the low-lying Italian landscape known as the Roman Campagna. Along with Robert Burley and Lee Friedlander, he spent six years photographing the urban parks of Frederick Law Olmsted for the Canadian Centre for Architecture, a project that considered Olmsted's parks as embodiments of a democratic utopian ideal and the extent to which their history has matched that rhetoric. Subsequent projects have focused on the slag heaps produced by asbestos mines in Quebec, the fourteen-mile-long fence erected near San Diego to deter would-be immigrants from Mexico and Central America from entering the United States, and the city of Lethbridge in an extended project that depicts the histories visible in its architecture and the interaction between urban expansion and the natural environment.

Usually devoid of people, James' precisely composed photographs trace human presence through their allusions to a complex set of histories: of building, occupation and deterioration that are visible in the surfaces his images record. This approach recalls Michel de Certeau's differentiation between "place," as an order in which elements are situated in their own distinct locations in an indication of univocal stability, and "space," as what de Certeau has described as "a practiced place" in which the ambiguous interaction of mobile elements disrupts such an order, a distinction clearly visible in the images that make up *Inside Kingston Penitentiary*.

After a period of negotiation with Corrections Canada, James was given access to almost the entire prison and was able to photograph many of the cells—including the inmates' extraordinary interventions, which ranged from simple inscriptions to elaborate painted murals—on the day they were vacated. As James puts it, at this moment the cells "were kind of like a corpse where the facial hairs were still growing," and the presence of the inmates was visible in items and images left behind: books, empty milk cartons, graffiti, paintings and messages inscribed into the prison walls. Some of these seem prosaic, like the inscription "Go Leafs Go" in *Pin-up, Upper E range*; some speak to a longing for the idyllic, as in the wall mural in *Double sized cell with mural, occupied by inmate incarcerated 26 years*. Others, as in *Wall drawing and prayer*, express despair and hope for redemption. Articulations of identity can be seen

in a floor-to-ceiling mural in *Cell decorated with Harley Davidson and East Van logos, Upper E*, in the inscription of "Nunavut" over a cell door in *Inuk inscription* and in the demarcation of space asserted in the declaration "This is Indian Land" in *Cell drawing by Aboriginal inmate*. Some, such as *Improvised screen, Lower E* simply evoke a desire for privacy from the prison's panoptic gaze, while the swastika in *Cell inscription white power* suggests more ominous tensions within the prison's population.

James' use of black and white film to photograph the penitentiary's architecture and colour to photograph the cells and social spaces—such as the interior of the visitor centre—heightens both the brutal, claustrophobic atmosphere of images such as *Stripped down segregation cell for violent offenders* and the absurdity of items such as the yellow, turquoise and pink children's play set that sits on the scruffy, caged-in front lawn of *Yard, private family visiting unit*. It's hard to imagine a child deriving any pleasure from a journey down a slide in such a bleak context and it's equally hard to imagine how the incongruous simulation of a suburban house and front yard could produce any sense of home during conjugal visits.

Given the percentage of Native people in the Canadian prison system, the teepee, lawn and picnic tables surrounded by chain-link fencing and razor wire in *Aboriginal ground* is slightly less incongruous than the family visiting unit. Whether or not this was intended, the enclosed space suggests a shrunken version of an Indian reserve, on which many of the inmates may have been born, evoking consideration of the social structures that contribute to the high proportion of Native inmates. Nonetheless, the interior of the teepee is shielded from surveillance and its location directly on the lawn implies some level of sovereignty, even if it's severely contained. *Change of seasons ceremony* counters this bleakness in its representation of a day-long ritual in which Native inmates prepared elk stew, arctic char, cedar tea and bannock, and received guidance from elders—all of which took place in and around the teepee. James participated in the ceremony, which occurred shortly before the prison closed, and these photographs are among the few in which inmates are directly portrayed.

68

James is well aware that a project like *Inside Kingston Penitentiary*—which provides a portal into a space that is highly charged in the public consciousness—runs the risk of becoming an excessively voyeuristic enterprise in which images of powerless people are conveyed to a more privileged audience, and his approach to the project reflects this. His photographs allude to the inmates' lived experience but avoid the sense of closure associated with the anecdotal. Though inmates are rarely depicted, their voices do have a compelling presence in the messages and drawings inscribed on their cell walls—images that have a crucial place in this body of work. And, if the representation of Kingston Penitentiary is expansive, the story is deliberately incomplete. While acknowledging the specifics of this prison's history, James situates it as a nexus within a larger set of social economies, including the circumstances that motivate behaviour defined as criminal and the penitentiary as an emblem of social value.

ENDNOTES

1 Geoffrey James, *Inside Kingston Penitentiary 1835–2013* (London: Black Dog Publishing; Kingston: Agnes Etherington Art Centre, 2014).

Geoffrey James
The visitors room, 2013

Geoffrey James
Wall drawing and prayer, 2013

70

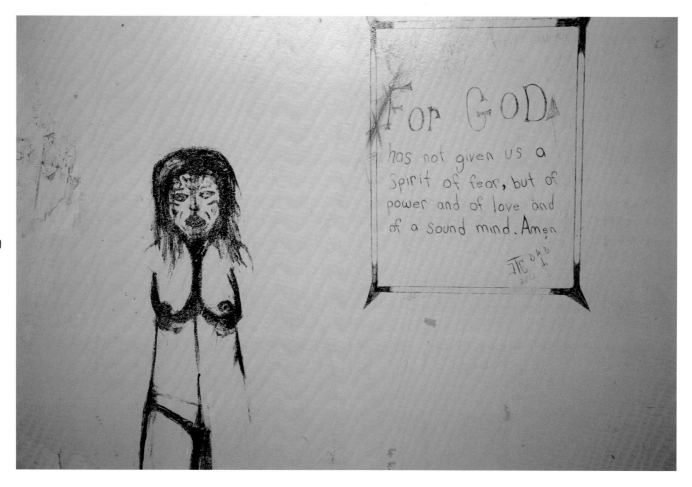

Geoffrey James
*Stripped down segregation cell
for violent offenders*, 2013

OVERLEAF Geoffrey James
The Dome from above, 2013

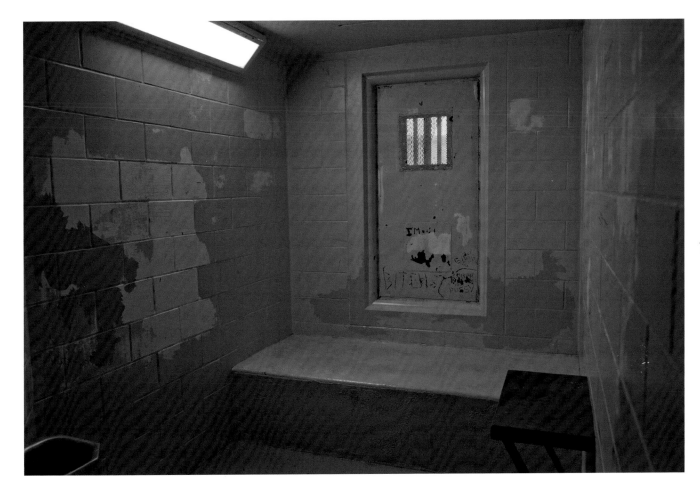

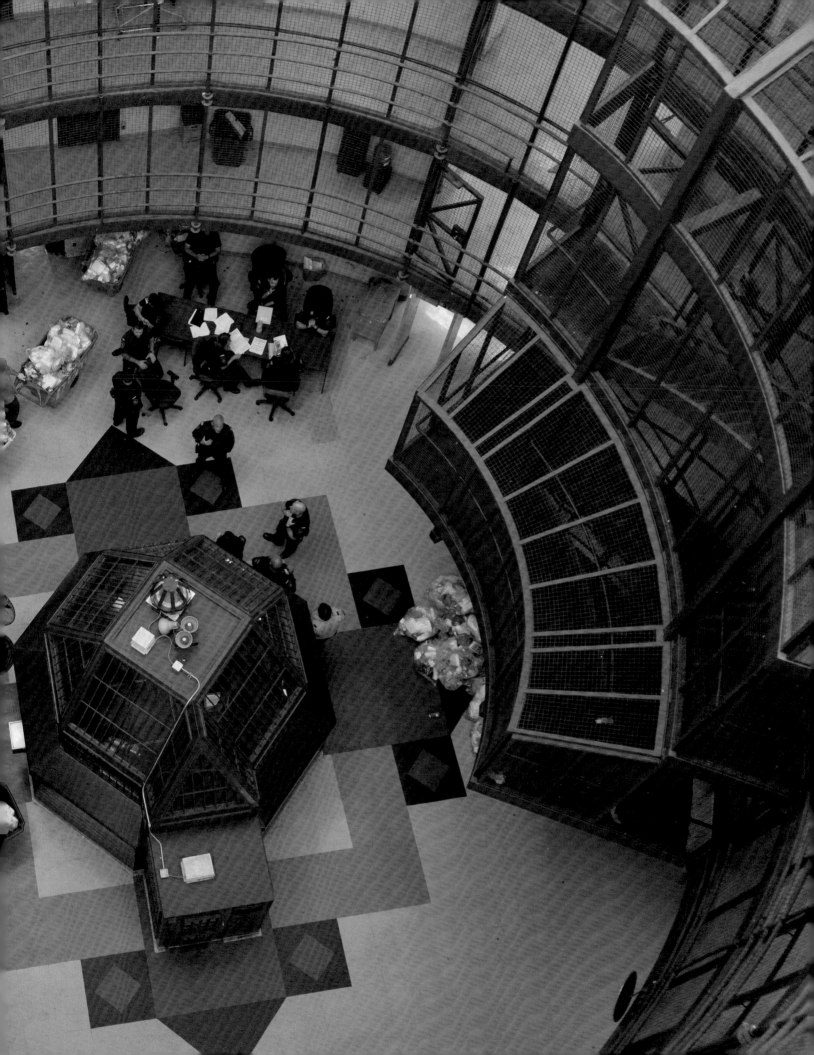

Geoffrey James
Cell decorated with Harley Davidson and East Van
logos, Upper E, 2013

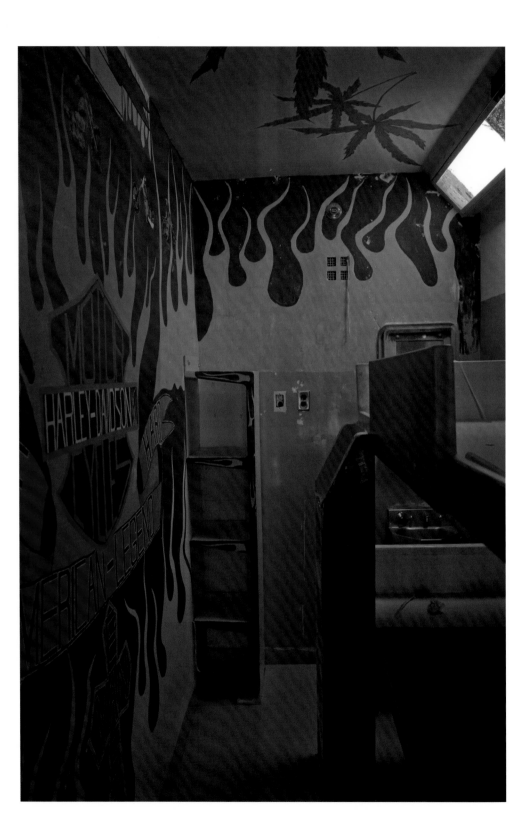

Geoffrey James
Inuk inscription, 2013

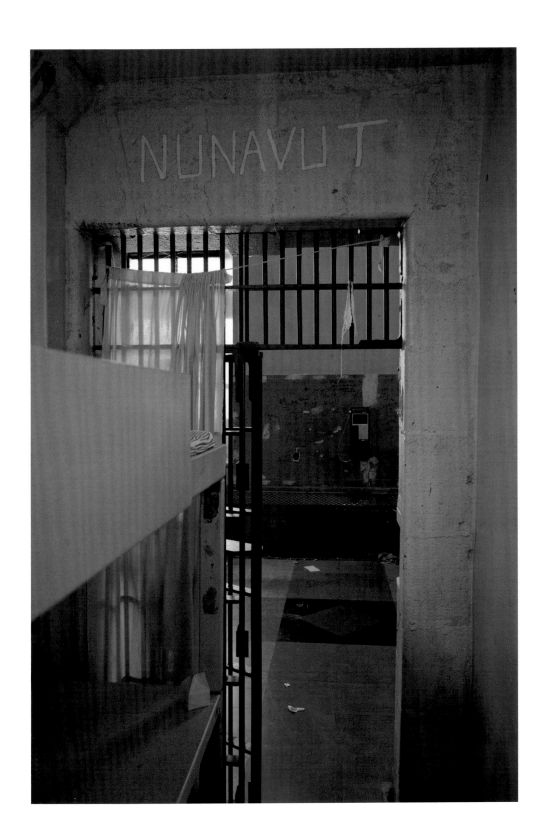

Geoffrey James
Double-sized cell with mural, occupied by inmate
incarcerated for 26 Years, 2013

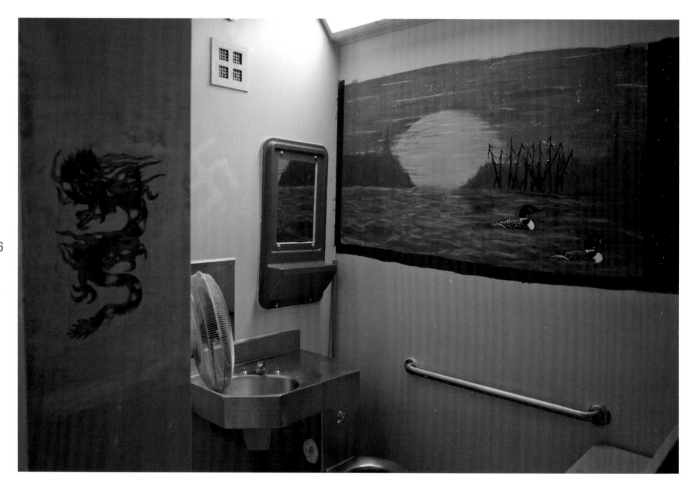

Geoffrey James
Yard, private family visiting unit,
2013

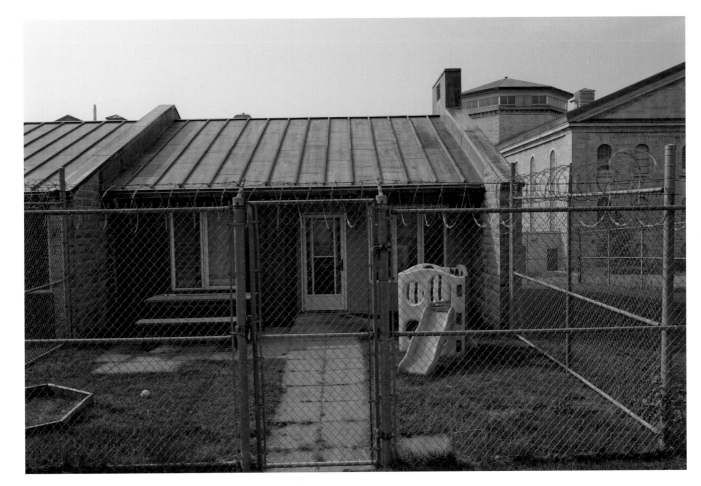

Geoffrey James
Aboriginal ground, 2013

78

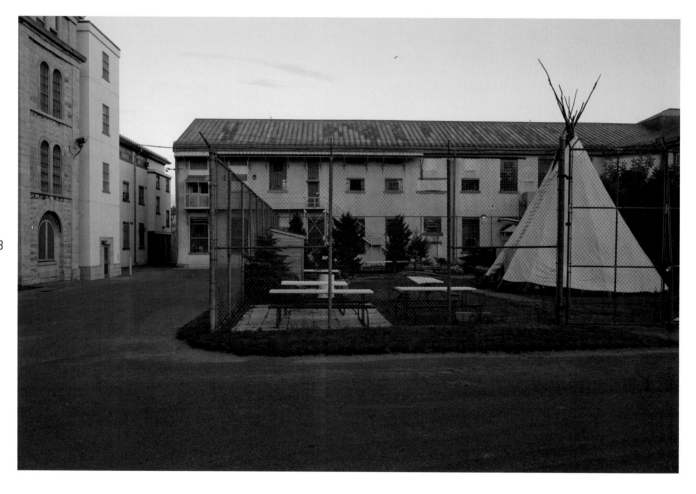

Geoffrey James
Change of seasons ceremony,
2013

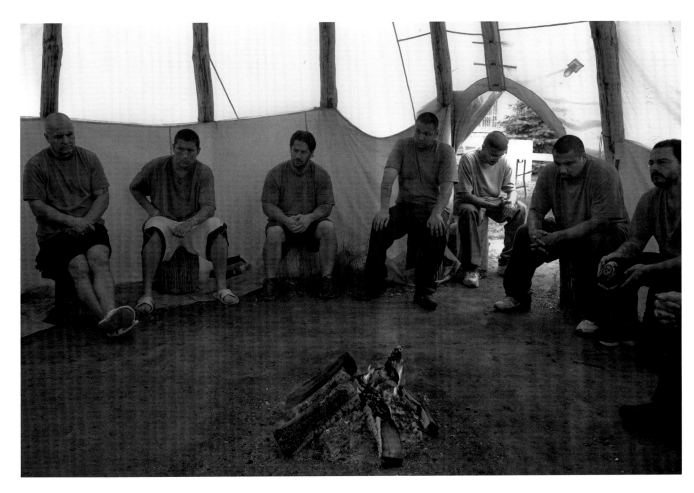

Geoffrey James
Gates to the new exercise yard,
2013

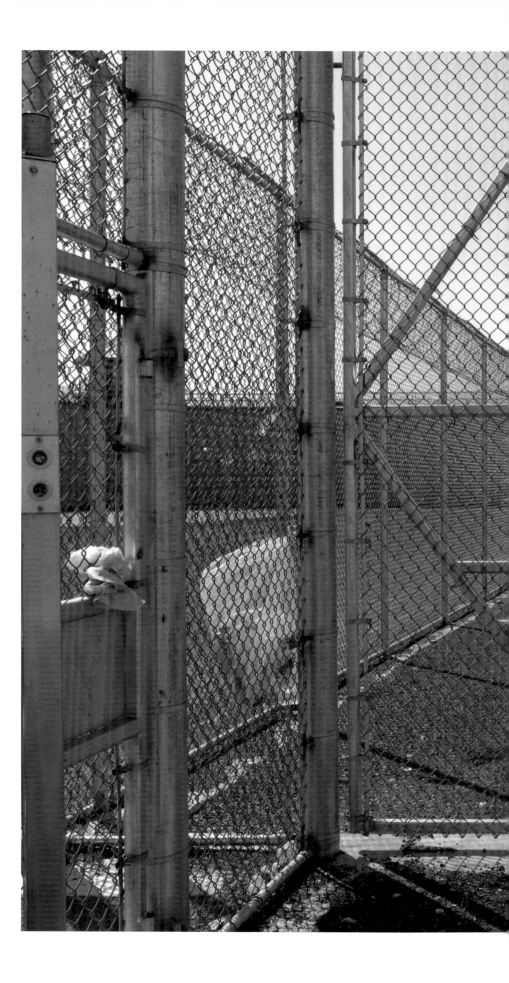

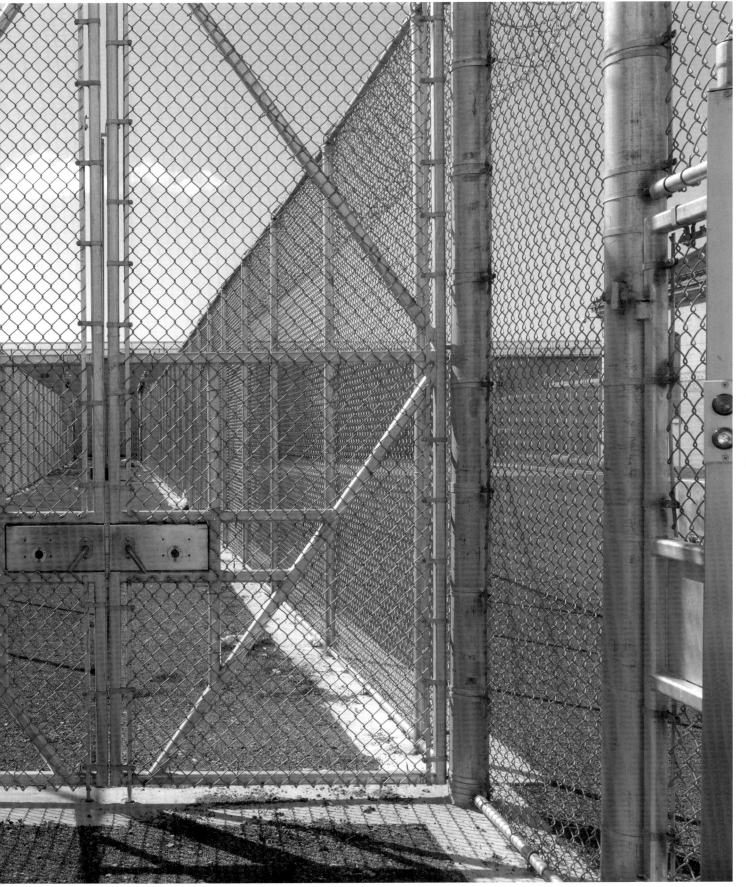

GEOFFREY JAMES

Brian Jungen and Duane Linklater
Modest Livelihood, 2012 (still)

82

BRIAN JUNGEN AND DUANE LINKLATER
MODEST LIVELIHOOD

Not much happens, in terms of conventional cinematic narrative, in the fifty minutes that comprise Brian Jungen and Duane Linklater's collaborative film project *Modest Livelihood*, but perhaps that's the point. Ostensibly documenting the two First Nations artists on a moose hunt in northeastern British Columbia, the film's slow pace and cinematographer Jesse Cain's elegant camera work create a space for a contemporary exploration of identity as navigated through connection to place.

Jungen and Linklater met at The Banff Centre in 2009, when Jungen was working on *The ghosts on top of my head*—an outdoor sculptural installation consisting of three benches in the form of caribou, elk and moose antlers—and Linklater was participating in a residency led by Ken Lum. Although born and raised in distant parts of the country, Jungen, who is of Dane-zaa ancestry and from northeastern British Columbia, and Linklater, who is Omaskêko Cree from northern Ontario, found common ground in their approach to art making as a way of addressing the processes of displacement of Native peoples and their cultures that are deeply embedded in Canadian history. Linklater subsequently invited Jungen on a family hunting trip in northern Ontario and, although no moose was bagged, the concept of *Modest Livelihood* developed out of that experience. In the fall of 2011 Linklater joined Jungen on his peoples' treaty land in northeastern British Columbia, where he participated in two five-day moose hunts under the guidance of Jungen's uncle and Dane-zaa elder, Jack Askoty. Cain recorded these hunts on fifty hours of super 16mm film stock, which Jungen and Linklater later edited down to fifty minutes.

Like most of the First Nations in Canada, the Dane-zaa have had to fight for the Canadian government's recognition of their treaty rights, and the seismic lines, logging cuts and natural gas flares that mark the landscape of *Modest Livelihood* speak to this struggle. The Dane-zaa's entitlement to 840,000 square kilometres of land was acknowledged by the government of Canada with the signing of Treaty 8 in 1899, which promised protection of the Dane-zaa's traditional way of life, including their hunting rights on ceded land. It goes without saying that the expansion of resource industries over the past few decades has severely compromised these promises; the marks etched into the land's surface are evidence of "a mighty industrial engine infiltrating the forest along with the hunters and their prey" and a clash between different world views.[1] By some accounts there are two versions of Treaty 8: an oral version that was legally binding in the eyes of the Dane-zaa and the written document, which is subject to differing interpretations within the Canadian legal system. This tension is reiterated in the film's title, which refers to a 1999 ruling by the Supreme Court of Canada that recognized the hunting and fishing rights of Native peoples to provide for their own sustenance—a "modest livelihood," rather than an "accumulation of wealth"—with the federal government maintaining the ultimate right to define the meaning of these terms.

The points of reference for *Modest Livelihood* include the depictions of indigenous ways of life in Robert Flaherty's *Nanook of the North* (1922)—a film that National Film Board of Canada (NFB) founder John Grierson both praised for its focus on the daily life of the Inuit hunter Nanook and criticized as a retreat into the exotic—as well as *Cree Hunters of the Mistassini* (1974), a film produced by the NFB and directed by Tony Ianzelo and Boyce Richardson that depicts five months in the lives of three Cree families as they set up their winter hunting camp in northern Quebec.[2] Both films are sympathetic portrayals; however,

while Flaherty screened takes from his film-in-progress for the Inuit participants in the project and the dialogue in *Cree Hunters* is almost entirely in Cree, the narrative arc of the films, together with the descriptive English text in *Nanook* and the English voice-over in *Cree Hunters*, make it clear that both films were intended for white urban audiences rather than the people they depict.

As the anthropologist and theorist Michael Taussig has noted, the cinematic modesty of *Modest Livelihood*—particularly its silence—makes it difficult for viewers to determine "what's going on or what things mean."[3] The film is often visually stunning, giving the viewer spectacular panoramic views that sweep across green and gold forests, capture the sun setting behind distant mountains and show the late afternoon sun through dense patches of swamp grass. At times we see the artists close-up, peering through binoculars at something we can't see, and in other moments their tiny, distant figures almost meld into the land. Some scenes focus on the mundane and others push the film beyond its material limit so that only the faintest traces of movement can be made out in the darkness. Even when we understand that the men we see are on a hunt, the film eludes conventional logic through the inclusion of images—details of grass trembling against a snowy background, for example—that have no discernible connection to the pursuit of their quarry. And, when a moose is at last encountered—a moment that would be the dramatic climax of a conventional documentary film—all we see is a blur in the twilight as the moose falls and, as Taussig puts it, "The landscape of vistas, of a nature 'out there', changes to close-ups of an 'in there'...in which the camera reveals unexpected textures and shapes," as Jungen and Linklater quickly eviscerate the carcass.[4]

The perplexing silence of *Modest Livelihood* and its refusal to provide instrumental clarity imply that there is more going on in the film than the pursuit of something to eat and that there are limits to what can be translated or explained. The resolute absence of sound emphasizes both the position of the viewer as a voyeur and the importance of oral knowledge passed from one generation to another as a vital cultural tradition. It suggests the importance of knowledge to power, and implicates a history in which knowledge given to Euro-Canadians has facilitated a catastrophic appropriation of Native cultures. By strategically withholding traditional knowledge, *Modest Livelihood* refutes a structure of representation in which Native peoples are voiceless objects to be analyzed. Through its silence, *Modest Livelihood* both safeguards oral knowledge as it is transmitted from uncle/elder to nephew and transforms an idiom of representation from ethnographic document to a vehicle for agency.

84

ENDNOTES

1 Michael Taussig, "Hunting and Looking," http://www.centrevox.ca/en/exposition/brian-jungen-et-duane-linklater-modest-livelihood.

2 *Nanook of the North* is acknowledged as being a mixture of fact and fiction. Dean W. Duncan, "Nanook of the North," http://www.criterion.com/current/posts/42-nanook-of-the-north.

3 Michael Taussig, "Hunting and Looking."

4 Ibid.

Brian Jungen and Duane Linklater
Modest Livelihood, 2012 (still)

Brian Jungen and Duane Linklater
Modest Livelihood, 2012 (stills)

86

Brian Jungen and Duane Linklater
Modest Livelihood, 2012 (stills)

OVERLEAF Brian Jungen and Duane Linklater
Modest Livelihood, 2012 (still)

91

92

93

Brian Jungen and Duane Linklater
Modest Livelihood, 2012 (stills)

94

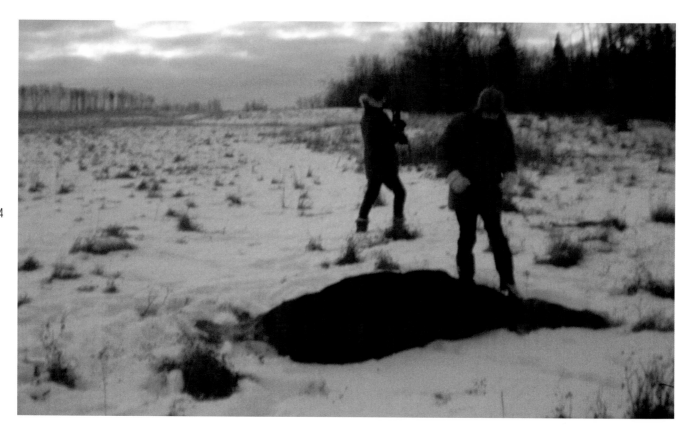

OVERLEAF Brian Jungen and Duane Linklater
Modest Livelihood, 2012
Installation view at Walter Phillips
Gallery, The Banff Centre, 2012

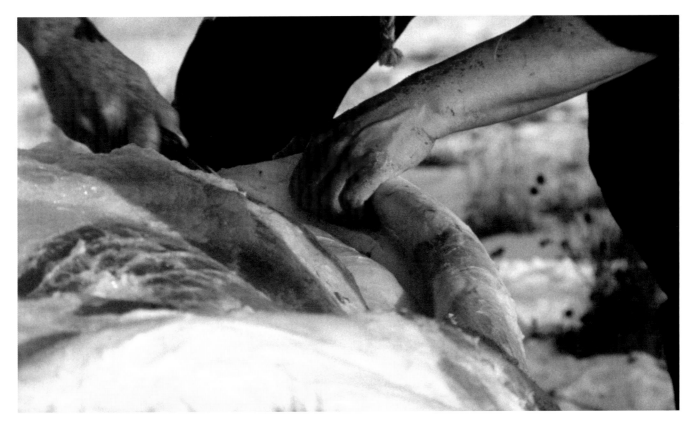

BRIAN JUNGEN AND DUANE LINKLATER

Catherine Opie
Jewelry Boxes #6
from the *700 Nimes Road Portfolio*, 2010–11

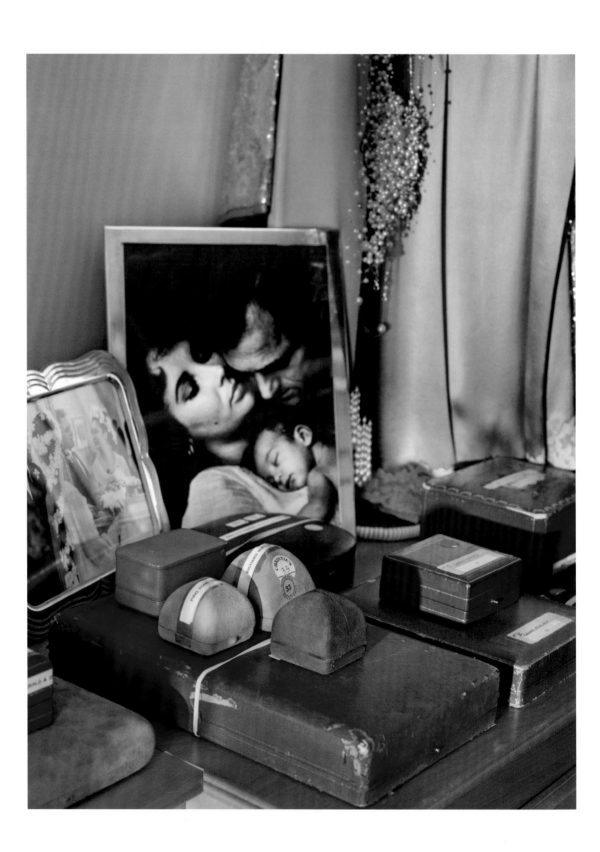

CATHERINE OPIE
ELIZABETH TAYLOR

Over the past three decades Los Angeles-based photographer Catherine Opie has produced a complex and multifaceted body of work that cuts across traditional genres such as portraiture, landscape and still life to address the roles of sexuality, gender and communal affinity in the construction of the self. Opie first began to exhibit her work in the early 1990s, a particularly intense moment in the American "culture wars," in which queer culture, reproductive choice and freedom of expression were targets of the religious right. Within this context, works such as *Being and Having* (1991), an early series of photographs of the West Coast lesbian S&M community of which she was a part, and *Portraits* (1993-97), a larger body of work depicting gay and lesbian friends, were forceful assertions of a presence that has traditionally been effaced from conventional conceptions of American culture.

The projects that followed included *Portraits, Domestic* (1995-98), for which Opie travelled across the United States photographing lesbian couples and their domestic environments, and *Houses* (1995-96), her portraits of Beverly Hills and Bel Air mansions. More recently she has focused on communities in which affiliation is attached to landscape, as in *Ice Houses* (2001)—images of Minnesota ice-fishing huts—and *Surfers* (2003), along with the images of her home, son, friends and neighbours that comprise the series *Around Home* (2004-5). During this time she also documented mini-malls and freeways in Los Angeles, as well as the urban landscapes of large American cities. These bodies of work formed the mid-career survey exhibition *Catherine Opie: American Photographer*, presented by the Guggenheim Museum in New York in the fall of 2008.

The title of the Guggenheim exhibition evokes *American Photographs,* Walker Evans' 1938 exhibition at the then relatively new Museum of Modern Art, which was intended as a cultural portrait of the eastern United States during a time of radical social change. The exhibition had a two-part structure: the first section focused on American culture as seen in portraits of individuals and their social contexts, and the second looked at the built environment—the main streets, wood houses and small churches of eastern factory towns and their surrounding villages. Opie's *American Photographer*—described as "an extraordinarily intimate... view of American lives"—covered similar subject matter and can be seen as a contemporary response to the portrayal of nationhood sketched out in Evans' images, one that proposes a nation in which lesbian, gay, bisexual and transgendered individuals are recognized as full-fledged citizens.

Opie began the *Elizabeth Taylor* project in 2010. She was initially approached by her accountant (who also worked for Taylor), who brought up the possibility of photographing the actor in her home. Opie initially rejected the idea, but later proposed a project that would portray Taylor through images of the spaces she inhabited and the objects she acquired and arranged, without any personal contact.

While Taylor herself is absent from Opie's photographs, her likeness appears regularly. *National Velvet Costume Test* (2010-11), for example, presents us with a full-length test shot from the 1944 film that launched the actor's career, depicting a twelve-year-old, jodhpur-clad Taylor perched above neat piles of magazines and paper, the monochrome grey tones of the photograph echoed in the neutral greys of Taylor's Mac laptop. In *Living Room West View* (2010-11), one of Andy Warhol's well-known portraits of Taylor gazes across a white shag carpet, over an ornamental mountain goat and out the window to her garden, while more intimate images not originally intended for public consumption populate *Elizabeth and Richard* (2010-11) and *Jewelry Boxes #6* (2010-11).

A sense of kitsch not usually associated with wealthy celebrities permeates many of these images. Clusters of tchotchkes and framed photographs of family and friends—including Michael Jackson—create the effect of a small shrine in *Bedside Table* (2010–11), while jewelled red-ribbon pins serve as a glimmering testament to Taylor's role as an *AIDS Activist* (2010–11). Opie's calculated framing of a wall of museum-quality impressionist paintings in *Paintings* (2010–11) is eloquently juxtaposed with the sentimental innocence of Taylor's painting that appears in *Deer in Snow* (2010–11). The sense of homeliness that marks the image of Taylor's cat, Fang, walking across her shoes could be middle class, if it weren't for the Chanel labels on their inner soles.

Like Opie's landscape photographs, many of the works in this series serve as carefully composed renderings of light, surface and texture. For example, the image of *La Peregrina* (2012), a necklace containing a famous pearl that was originally found by an African slave in 1513 and was once part of the crown jewels of Spain, sits just out of our visual grasp in a state of soft-focus abstraction. Equally compelling are the photographs of Taylor's closets. The close-up view restricts any sense of depth and the images become meditations on texture and colour, the lush swaths of cloth, fur and leather pulsing with rhythm. In photographs such as *Untitled # 5* (2012) and *Untitled # 7* (2012), Opie takes fetishized objects of glamour—such as silk dresses and fur coats—and presents them as Taylor would have seen them: garments crowded in a closet, awaiting the occasion when they would next be worn. The fetishized status of these objects is poignantly reiterated in images such as *Treasure* (2010–11), which was made after Taylor's death and depicts items that have been packed and labelled in preparation for the auction of her estate.

These images are not easily resolved. Although the intimate observation of the possessions and spaces Taylor inhabited might trigger recognition of the processes through which we all construct identity, and while the actor spent much of her life in public view, the authentic Taylor remains out of our reach. Instead, Opie's refracted portrait leaves us to consider fragments of her lived experience and their entanglement in spectatorship and celebrity, extravagance and kitsch, fame and mortality.

Catherine Opie
Bedside Table
from the *700 Nimes Road Portfolio*, 2010–11

Catherine Opie
Living Room West View
from the *700 Nimes Road Portfolio*, 2010–11

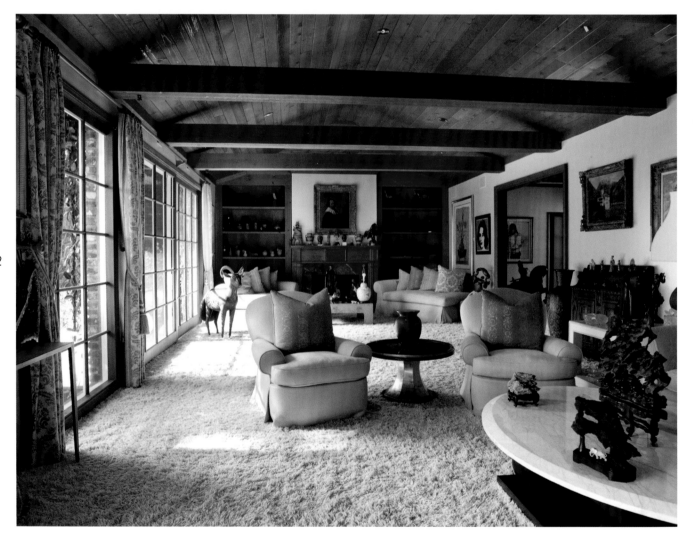

Catherine Opie
National Velvet Costume Test
from the *700 Nimes Road Portfolio*, 2010–11

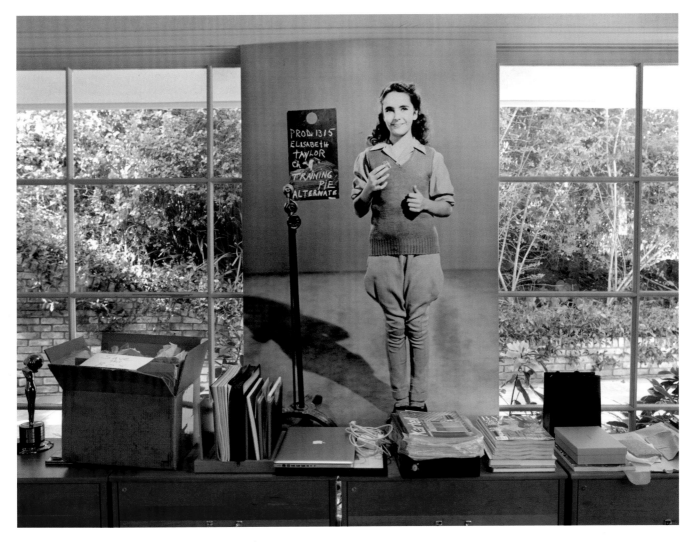

Catherine Opie
Jewels in Afternoon Light #1, 2012

OPPOSITE Catherine Opie
AIDS Activist
from the *700 Nimes Road Portfolio*,
2010–11

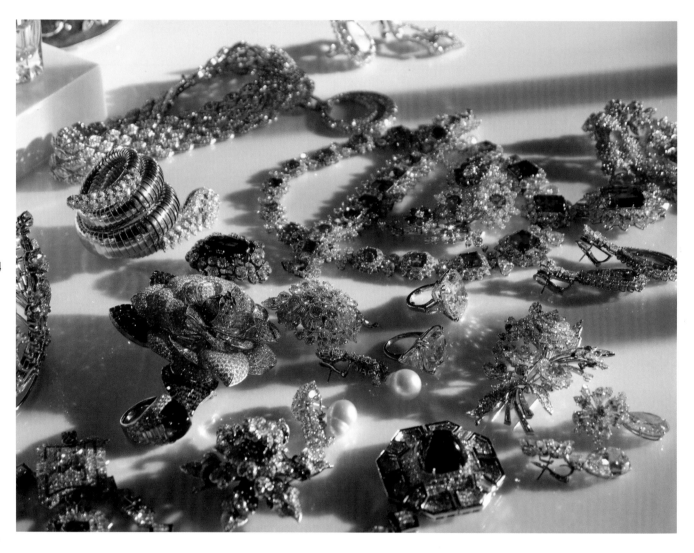

104

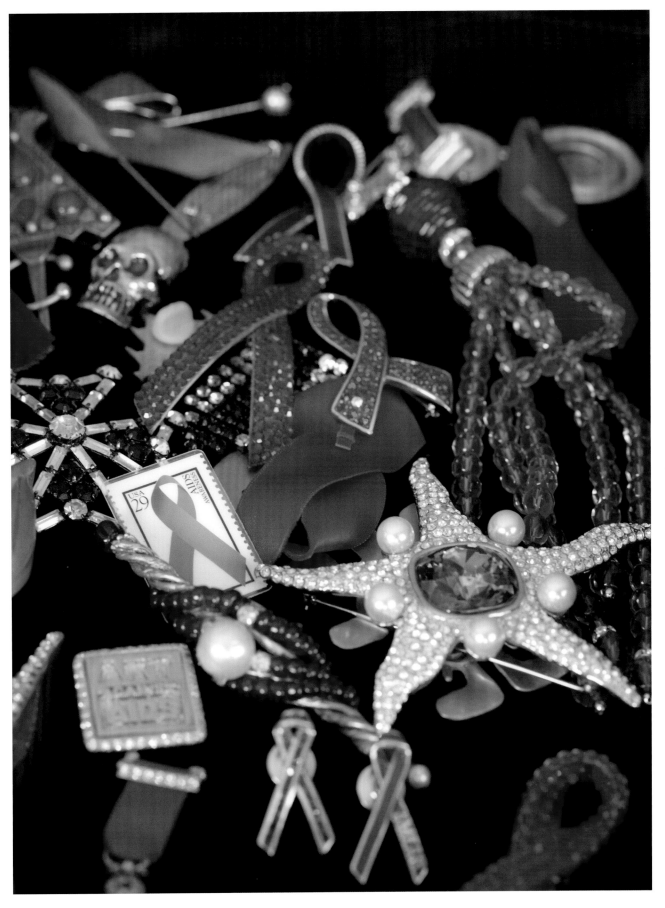

CATHERINE OPIE

Catherine Opie
Elizabeth and Richard
from the *700 Nimes Road Portfolio*, 2010–11

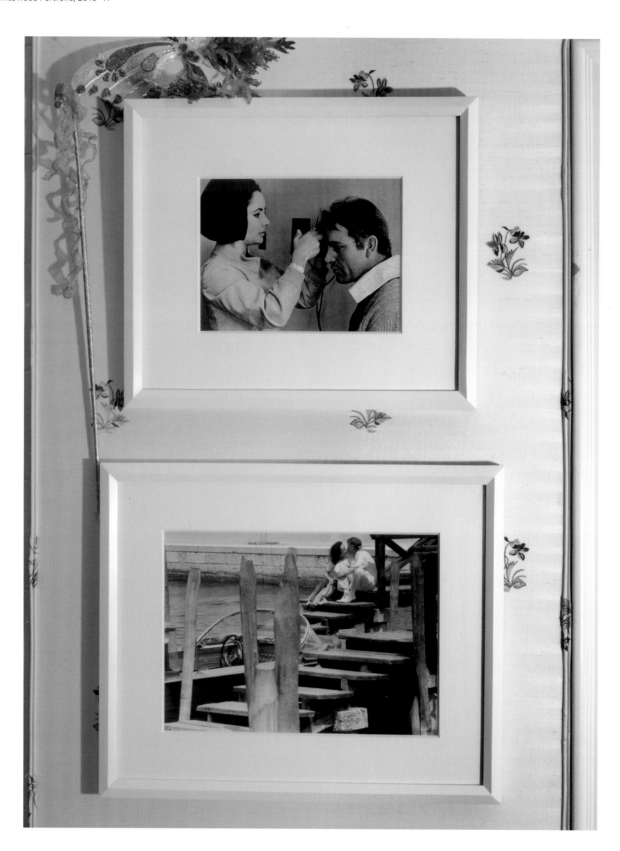

Catherine Opie
Treasure
from the *700 Nimes Road Portfolio*, 2010–11

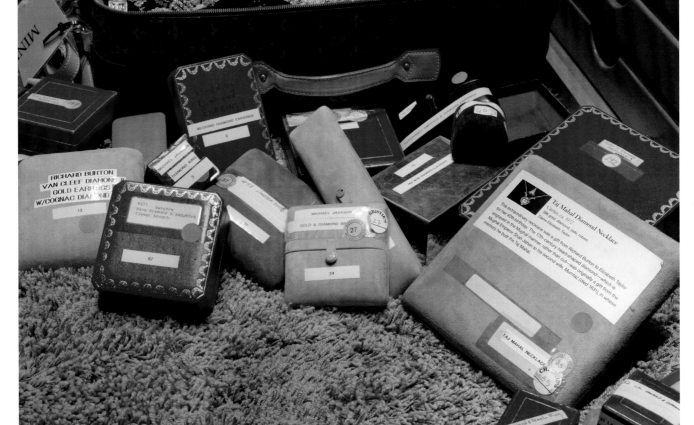

Catherine Opie
Untitled #3
(Elizabeth Taylor's Closet), 2012

Catherine Opie
Untitled #11
(Elizabeth Taylor's Closet), 2012

Catherine Opie
Untitled #7
(Elizabeth Taylor's Closet), 2012

Catherine Opie
Untitled #1
(Elizabeth Taylor's Closet), 2012

Catherine Opie
Fang and Chanel
from the *700 Nimes Road Portfolio*, 2010–11

110

Catherine Opie
Emeralds, 2012

Catherine Opie
La Peregrina (Elizabeth Taylor),
2012

113

Amie Siegel
Provenance, 2013
Installation view at Simon Preston Gallery,
New York, 2013

114

Over the past fifteen years the New York–based artist Amie Siegel has produced an expansive and multifaceted corpus of work in film, performance, installation and photography for presentation in cinemas as well as in galleries and museums. Her recent work, including *Provenance* (2013), has reflexively employed the tropes and forms of cinema to consider the intersection of history, place and representation. Following the model of an artwork's ownership chronology, *Provenance* moves backwards through time as it tracks the itinerary of furniture designed in the 1950s by Pierre Jeanneret for Le Corbusier's planned city of Chandigarh, moving from the residences of wealthy collectors in the United States and Europe across the Indian Ocean to its putative place of origin.

The only one of Le Corbusier's urban master plans to be realized, Chandigarh was built during the 1950s to replace Lahore as the capital of the Indian states of Haryana and Punjab, following the partition of India and Pakistan. Commissioned by then president of India, Jawaharlal Nehru, Le Corbusier's design for the city was intended to break with the building conventions of the Raj: to be "unfettered by the traditions of the past" and to provide a symbol for the Indian "nation's faith in the future." The plan encompassed almost every facet of the city—from the layout of its streets and the architecture of its buildings, to the design of its doorknobs. In its rhetoric, at least, Chandigarh's plan paid substantial attention to the local environment and the living habits of its populace, with an emphasis on parks, extensive plantings of trees and the use of concrete as an inexpensive and locally sourced building material. Similarly, Jeanneret's furniture designs used local materials such as teak, and were produced using local labour. Six decades later Jeanneret's furniture is being discarded or put into storage—rather than being refurbished as it falls into disrepair—and is replaced by contemporary modular workstations for the city's civil service. It has become common for antique dealers from Europe and the United States to purchase large quantities of cast-off chairs, benches, sofas and daybeds in order to have them restored and sell them to wealthy collectors of high-end furniture—a market in which rescuing culturally significant artifacts from ruin in the Third World holds a certain currency.

From *Provenance*'s opening scenes, in which the camera moves slowly through elegantly spare residences in London, Antwerp, Paris and New York, to its closing depictions of government offices and a sparsely equipped classroom in Chandigarh, Siegel's video unfolds through extended sequences of establishing and parallel-tracking shots, each inscribing a protracted sense of anticipation as to what will appear next. Traversing reference points configured by wealth and geography, we move from the interiors of a Parisian auction house to a studio where a pair of chairs are being photographed and a restorer's workshop where worn fabric is ripped from the furniture's wooden frames, before briefly coming to rest on a container ship that delivers us to India, where monkeys scamper across concrete facades and piles of dilapidated Jeanneret chairs are stacked in front of a panoramic vista of Le Corbusier's General Legislative Assembly.

Siegel has described *Provenance* as "the most Hollywood film" she has ever made, "in its use of establishing shots, in the timed acts of disclosure, but also in the production of desire."[1] The projected image as a locus of desire comes into play right at the start, as an *Architectural Digest* aesthetic is deployed in the scenes of the collector's stylish homes: the lights are on, the fireplace is lit, the detail of each upholstered surface is rendered in high definition and, though we may occasionally hear footsteps, the rooms are generally empty—open to psychic occupation yet somehow unobtainable. And, while the narrative arc of the video opens up the process of the furniture's fetishization, the desirability of each

piece as an object does not fully dissipate as its numbers and origin are revealed. There's something vaguely pornographic in the positioning of the viewer as a voyeur in the slow but persistent lateral tracking of the camera, which never dwells on any particular object and leaves the viewer emotionally detached from the scene, and in the audio, which shuns dialogue or voice-over and is comprised entirely of ambient sound that often implies an unseen human presence.

After completing *Provenance*, Siegel produced two additional components that mirror the circulation of the objects the film depicts. The first, titled *Lot 248*, is a video record of the sale of one film from *Provenance*'s edition of five at the fall 2013 auction of Post-War and Contemporary Art at Christie's Auction House in London, where it achieved a price roughly equivalent to the hammer price attained by the Chandigarh furniture in her film. *Proof*, the second component, is a wall-mounted work consisting of the page from the Christie's auction catalogue with the image and information related to *Provenance* that has been embedded in Lucite.

While Siegel's depiction of the traffic in Chandigarh's furniture clearly carries a critique of the inequity that is still plainly visible in colonialism's wake, as well as the processes of commodification that lie at the heart of capitalist ideology, the project opens onto broader and more nuanced considerations on the means through which desire is produced and value is constructed by positioning artist and viewer as at least partially complicit in the mechanisms it represents and enacts. It both marks the deflation of the promise attached to Modernism's deployment in Chandigarh and serves as an allegory for the condition of art in general, through which we might ponder the currency of Clement Greenberg's famous observation that the avant-garde has always remained tied to the bourgeoisie "by an umbilical cord of gold."[2]

ENDNOTES

1 Amie Siegel, "1000 Words: Amie Siegel Talks About *Provenance*, 2013," in *Artforum International*, http://artforum.com/imprintarchive/id=44374.

2 Clement Greenberg, "Avant-Garde and Kitsch," in *Partisan Review*, vol. 6, no. 5 (Fall 1939): 38.

117

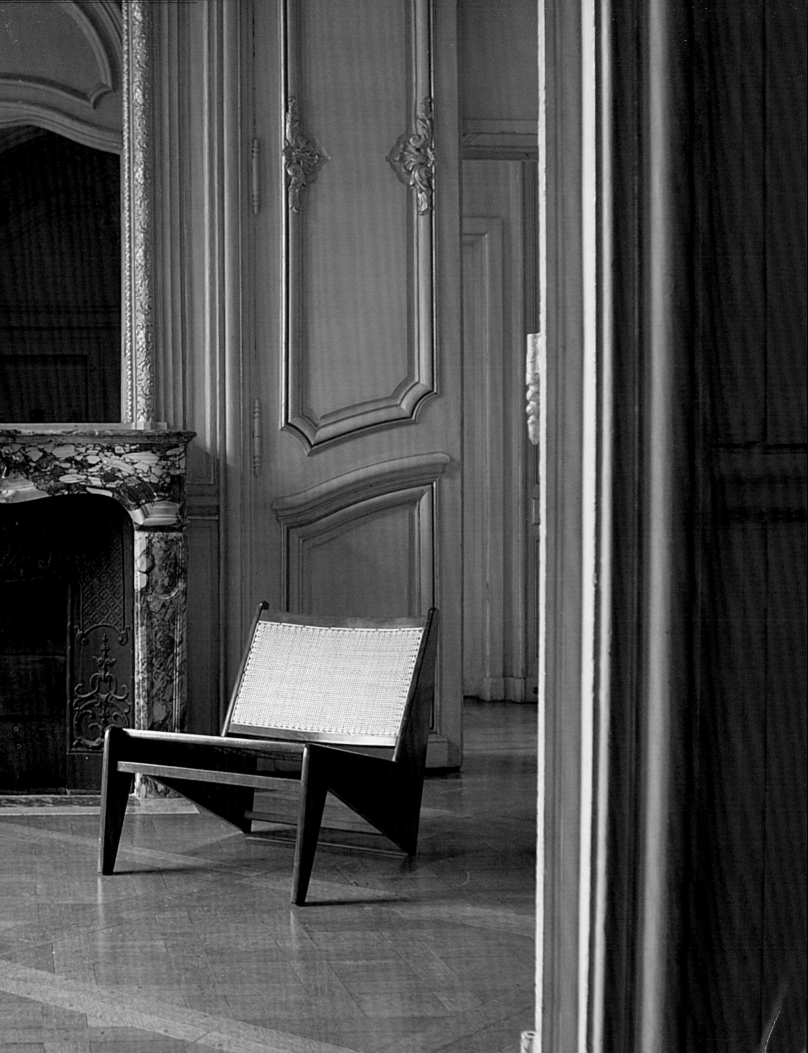

Amie Siegel
Provenance, 2013 (stills)

AMIE SIEGEL

Amie Siegel
Provenance, 2013
Installation view at Simon Preston
Gallery, New York, 2013

122

AMIE SIEGEL

Amie Siegel
Provenance, 2013 (stills)

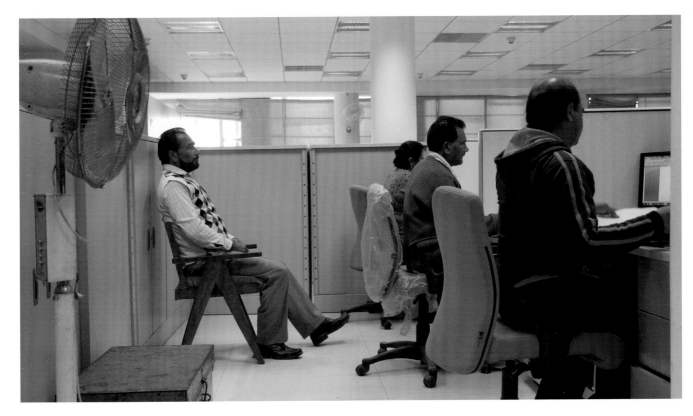

Amie Siegel
Provenance, 2013 (stills)

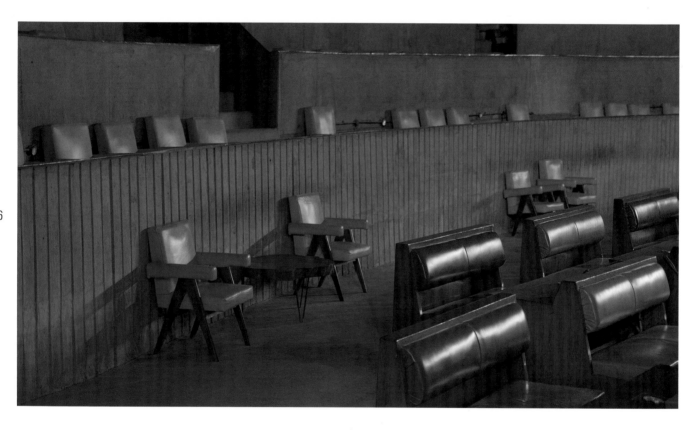

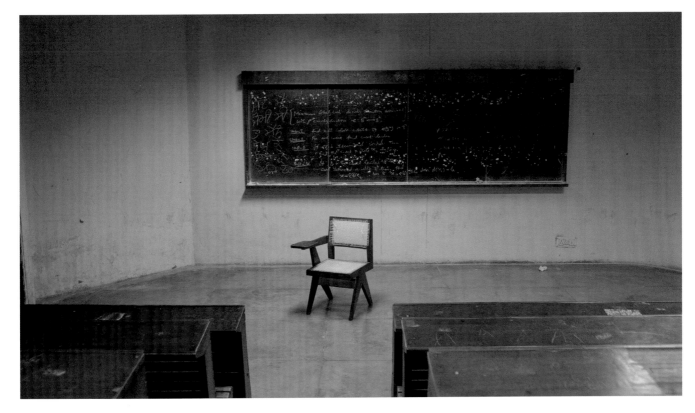

AMIE SIEGEL

Amie Siegel
Proof (Christie's 19 October, 2013), 2013

128

Amie Siegel
Lot 248, 2013 (still)

LIST OF WORKS

ROBERT BURLEY

Darkroom, Building 3, Kodak Canada, Toronto, 2005
archival ink jet print mounted on Dibond
76.2 x 99.06 cm
Courtesy of Stephen Bulger Gallery

Executive Entrance, Building 7, Kodak Canada, Toronto, 2005
archival ink jet print mounted on Dibond
Courtesy of Stephen Bulger Gallery

Faded Proof, 2005–12
48 gelatin silver prints (Polaroid type 55)
10.8 x 14.6 cm each
Courtesy of Stephen Bulger Gallery

Administrative Area, Building 7, Kodak Canada, Toronto, 2006
archival ink jet print mounted on Dibond
60.96 x 76.2 cm
Courtesy of Stephen Bulger Gallery

Executive Office, Building 7, Kodak Canada, Toronto, 2006
archival ink jet print mounted on Dibond
60.96 x 76.2 cm
Courtesy of Stephen Bulger Gallery

After the Implosions of Buildings 65 and 69, Kodak Park, Rochester, New York, 2007
archival ink jet print mounted on Dibond
76.2 x 99.06 cm
Courtesy of Stephen Bulger Gallery

Awaiting the Implosions of Buildings 65 and 69, Kodak Park, Rochester, New York, 2007
archival ink jet print mounted on Dibond
76.2 x 99.06 cm
Courtesy of Stephen Bulger Gallery

Implosions of Buildings 65 and 69, Kodak Park, Rochester, New York (#1), 2007
archival ink jet print mounted on Dibond
76.2 x 99.06 cm
Courtesy of Stephen Bulger Gallery

Implosions of Buildings 65 and 69, Rochester, New York (#2), 2007
archival ink jet print mounted on Dibond
76.2 x 99.06 cm
Courtesy of Stephen Bulger Gallery

Film Coating Facility, Agfa-Gevaert, Mortsel, Belgium, (#1), 2007
archival ink jet print mounted on Dibond
76.2 x 99.06 cm
Courtesy of Stephen Bulger Gallery

Film Warehouse, Agfa-Gevaert, Mortsel, Belgium, 2007
archival ink jet print mounted on Dibond
76.2 x 99.06 cm
Courtesy of Stephen Bulger Gallery

Employee Identification Board, Polaroid, Enschede, The Netherlands, 2010
archival ink jet print mounted on Dibond
60.96 x 76.2 cm
Courtesy of Stephen Bulger Gallery

Empty Offices, Polaroid, Enschede, The Netherlands, 2010
archival ink jet print mounted on Dibond
60.96 x 76.2 cm
Courtesy of Stephen Bulger Gallery

Photograph in Stairwell, Paper Finishing Building, Ilford, Mobberley, United Kingdom, 2010
archival ink jet print mounted on Dibond
60.96 x 76.2 cm
Courtesy of Stephen Bulger Gallery

Blowups, 2013
looped video, 6 min 3 sec
Courtesy of Stephen Bulger Gallery

Extermination Music Night XI at the Kodak Factory. Got busted by the cops after the first song, 2013
slideshow of 19 JPEGs displayed on an iPhone Model 2G
23.18 x 28.26 cm
Courtesy of Stephen Bulger Gallery

STAN DOUGLAS

Luanda-Kinshasa, 2013
single-channel video projection, 6 hours 1 min (loop)
dimensions variable
Courtesy of the Artist, David Zwirner, New York/London and Victoria Miro, London

BABAK GOLKAR

Brancusi's Alien Fascination (including *Constantin*), 2014
chromogenic print, steel, wood, stain
dimensions variable
Collection of the Vancouver Art Gallery, Purchased with proceeds from the Audain Emerging Artists Acquisition Fund

Fair Trade (including *Assisted Reconstruction*), 2014
mixed-media installation
dimensions variable
Private Collection

From Africa to the Americas (including *To Cubism*), 2014
chromogenic print, wood, stain, Plexiglas
dimensions variable
Collection of the Vancouver Art Gallery, Purchased with proceeds from the Audain Emerging Artists Acquisition Fund

RUN (including *URN*), 2014
transmounted Duratrans lightbox, wood, steel, yoga mat foam
dimensions variable
Promised Gift of the Artist to the Vancouver Art Gallery

Tearless (including *Never Forgetting Richter*), 2014
chromogenic print, wax, cotton, wood
dimensions variable
Collection of the Vancouver Art Gallery, Purchased with proceeds from the Audain Emerging Artists Acquisition Fund

The Rise of the Sun (including *The Fall of the Sun*), 2014
chromogenic print, textile, rubber
dimensions variable
Collection of the Vancouver Art Gallery, Purchased with proceeds from the Audain Emerging Artists Acquisition Fund

GEOFFREY JAMES

Aboriginal ground, 2013
archival ink jet print
60.96 x 91.44 cm
Courtesy of the Artist

Armed guard outside Tower 3, 2013
archival ink jet print
35.56 x 53.34 cm
Courtesy of the Artist

Book drop-off in the Dome, with absorption pad for warning shots, 2013
archival ink jet print
35.56 x 53.34 cm
Courtesy of the Artist

Cell decorated with Harley Davidson and East Van logos, Upper E, 2013
archival ink jet print
40.64 x 26.67 cm
Courtesy of the Artist

Cell drawing by Aboriginal inmate, 2013
archival ink jet print
26.67 x 40.64 cm
Courtesy of the Artist

Cell inscription white power, 2013
archival ink jet print
26.67 x 40.64 cm
Courtesy of the Artist

Cell mural by Inuk inmate, 2013
archival ink jet print
35.56 x 53.34 cm
Courtesy of the Artist

Cell with landscape photographs, 2013
archival ink jet print
60.96 x 91.44 cm
Courtesy of the Artist

Change of seasons ceremony, 2013
archival ink jet print
35.56 x 53.34 cm
Courtesy of the Artist

Change of seasons ceremony 2, 2013
archival ink jet print
35.56 x 53.34 cm
Courtesy of the Artist

Decorated cell, Upper E, 2013
archival ink jet print
53.34 x 35.56 cm
Courtesy of the Artist

132 *Double-sized cell with mural, occupied
by inmate incarcerated for 26 Years*, 2013
archival ink jet print
35.56 x 53.34 cm
Courtesy of the Artist

Gates to the new exercise yard, 2013
archival ink jet print
35.56 x 53.34 cm
Courtesy of the Artist

Improvised screen, Lower E, 2013
archival ink jet print
40.64 x 26.67 cm
Courtesy of the Artist

*In front of the white board, with the location
of every inmate*, 2013
archival ink jet print
35.56 x 53.34 cm
Courtesy of the Artist

Inmate reading material, 2013
archival ink jet print
35.56 x 53.34 cm
Courtesy of the Artist

Inmates passing through the Dome, 2013
archival ink jet print
35.56 x 53.34 cm
Courtesy of the Artist

Inuk inscription, 2013
archival ink jet print
40.64 x 26.67 cm
Courtesy of the Artist

*Lower E, with a notice advertising
sexual services*, 2013
archival ink jet print
35.56 x 53.34 cm
Courtesy of the Artist

Pin-up, Upper E range, 2013
archival ink jet print
53.34 x 35.56 cm
Courtesy of the Artist

Poster designed by inmates, 2013
archival ink jet print
40.64 x 26.67 cm
Courtesy of the Artist

*Recently vacated cell with milk cartons,
Upper G*, 2013
archival ink jet print
40.64 x 26.67 cm
Courtesy of the Artist

Shadow board, plumbing workshop, 2013
archival ink jet print
35.56 x 53.34 cm
Courtesy of the Artist

*Stripped down segregation cell for
violent offenders*, 2013
archival ink jet print
60.96 x 91.44 cm
Courtesy of the Artist

The Dome from above, 2013
archival ink jet print
60.96 x 91.44 cm
Courtesy of the Artist

The visitors room, 2013
archival ink jet print
60.96 x 91.44 cm
Courtesy of the Artist

Wall drawing and prayer, 2013
archival ink jet print
26.67 x 40.64 cm
Courtesy of the Artist

Yard, private family visiting unit, 2013
archival ink jet print
35.56 x 53.34 cm
Courtesy of the Artist

BRIAN JUNGEN AND DUANE LINKLATER

Modest Livelihood, 2012
Super 16mm film, transferred to Blu-ray
50 minutes, silent
Courtesy of the Artists and Catriona Jeffries Gallery,
Vancouver

CATHERINE OPIE

AIDS Activist
from the *700 Nimes Road Portfolio*, 2010–11
archival ink jet print
50.8 x 41.91 cm
Courtesy of the Artist and Regen Projects,
Los Angeles

Bedroom Shelf #3
from the *700 Nimes Road Portfolio*, 2010–11
archival ink jet print
41.91 x 50.8 cm
Courtesy of the Artist and Regen Projects,
Los Angeles

Bedside Table
from the *700 Nimes Road Portfolio*, 2010–11
archival ink jet print
50.8 x 41.91 cm
Courtesy of the Artist and Regen Projects,
Los Angeles

Deer in Snow
from the *700 Nimes Road Portfolio*, 2010–11
archival ink jet print
50.8 x 41.91 cm
Courtesy of the Artist and Regen Projects,
Los Angeles

Elizabeth and Richard
from the *700 Nimes Road Portfolio*, 2010–11
archival ink jet print
50.8 x 41.91 cm
Courtesy of the Artist and Regen Projects,
Los Angeles

Fang and Chanel
from the *700 Nimes Road Portfolio*, 2010–11
archival ink jet print
41.91 x 50.8 cm
Courtesy of the Artist and Regen Projects,
Los Angeles

Gown Storage Boxes
from the *700 Nimes Road Portfolio*, 2010–11
archival ink jet print
50.8 x 41.91 cm
Courtesy of the Artist and Regen Projects,
Los Angeles

Jewelry Boxes #6
from the *700 Nimes Road Portfolio*, 2010–11
archival ink jet print
50.8 x 41.91 cm
Courtesy of the Artist and Regen Projects,
Los Angeles

Living Room West View
from the *700 Nimes Road Portfolio*, 2010–11
archival ink jet print
41.91 x 50.8 cm
Courtesy of the Artist and Regen Projects,
Los Angeles

National Velvet Costume Test
from the *700 Nimes Road Portfolio*, 2010–11
archival ink jet print
41.91 x 50.8 cm
Courtesy of the Artist and Regen Projects, Los Angeles

Paintings
from the *700 Nimes Road Portfolio*, 2010–11
archival ink jet print
41.91 x 50.8 cm
Courtesy of the Artist and Regen Projects,
Los Angeles

Treasure
from the *700 Nimes Road Portfolio*, 2010–11
archival ink jet print
41.91 x 50.8 cm
Courtesy of the Artist and Regen Projects, Los Angeles

Emeralds, 2012
archival ink jet print
101.6 x 135.4 cm
Collection of Hilary Tisch

Jewels in Afternoon Light #1, 2012
archival ink jet print
76.2 x 101.6 cm
Collection of Maurice Marciano

La Peregrina (Elizabeth Taylor), 2012
archival ink jet print
101.6 x 134.6 cm
Collection of Brenda R. Potter

Untitled #1 (Elizabeth Taylor's Closet), 2012
archival ink jet print
101.6 x 76.2 cm
Private Collection

Untitled #3 (Elizabeth Taylor's Closet), 2012
archival ink jet print
101.6 x 76.2 cm
Courtesy of the Artist and Regen Projects,
Los Angeles

Untitled #5 (Elizabeth Taylor's Closet), 2012
archival ink jet print
101.6 x 76.2 cm
Collection of Carole Bayer Sager

Untitled #7 (Elizabeth Taylor's Closet), 2012
archival ink jet print
101.6 x 76.2 cm
Collection of John McIlwee and Bill Damaschke

Untitled #8 (Elizabeth Taylor's Closet), 2012
archival ink jet print
101.6 x 76.2 cm
Courtesy of the Artist and Regen Projects,
Los Angeles

Untitled #10 (Elizabeth Taylor's Closet), 2012
archival ink jet print
101.6 x 76.2 cm
Collection of Paul and Amanda Attanasio

Untitled #11 (Elizabeth Taylor's Closet), 2012
archival ink jet print
101.6 x 76.2 cm
Courtesy of the Artist and Regen Projects,
Los Angeles

Yellow Diamonds Abstract, 2012
archival ink jet print
101.6 x 135.4 cm
Courtesy of the Artist and Regen Projects,
Los Angeles

AMIE SIEGEL

Lot 248, 2013
HD video
Courtesy of the Artist and Simon Preston Gallery,
New York

Proof (Christie's 19 October, 2013), 2013
archival ink jet print, Lucite
47 x 64.8 x 5 cm
Courtesy of the Artist and Simon Preston Gallery,
New York

Provenance, 2013
HD video
Courtesy of the Artist and Simon Preston Gallery,
New York

ROBERT BURLEY

Born 1957, Picton, Ontario
Lives and works in Toronto

EDUCATION

Master of Fine Arts, Photography, The School of Art
Institute of Chicago, 1984–86
Bachelor of Applied Arts, Media Studies, Ryerson
University, Toronto, 1975–80
Part-time studies, Fine Art History, University of
Toronto, 1976–77/1983–84

SELECT SOLO EXHIBITIONS SINCE 2005

2014
Disappearance of Darkness, Ryerson Image
Centre, Toronto; C/O Berlin; Musée Nicéphore
Niépce, Chalon-sur-Saône; National Gallery of
Canada, Ottawa

2009
Photographic Proof, photomontage of the installation
on the Canadian Centre for Architecture's north
facade for Le Mois de la Photo à Montréal and the
Canadian Centre for Architecture, Montreal

2007
Glenn Gould, Stephen Bulger Gallery, Toronto

2006
Great Lakes, Stephen Bulger Gallery, Toronto

2005
Instruments of Faith: Toronto's First Synagogues,
Eric Arthur Gallery, Toronto

SELECT GROUP EXHIBITIONS SINCE 2005

2013
A Noble Line, Oakville Galleries, Ontario

2012
Arcadian Land: Seized or Lost?, Art Gallery of Ontario,
Toronto
Back to the Land, National Gallery of Canada, Ottawa

2011
Spaces of the City, National Gallery of Canada,
Ottawa

2010
*Persistent Shadow: Considering the Photographic
Negative*, George Eastman House, International
Museum of Photography & Film, Rochester

2009
Liquid of Rain and Rivers, Art Gallery of Hamilton,
Ontario

2008
State of City, Rochester Contemporary Art Centre
*Between Memory & History: From the Epic to the
Everyday*, Museum of Contemporary Canadian Art,
Toronto
The Death of Photography, Stephen Bulger Gallery,
Toronto (catalogue)

2005
Sense of the City, Canadian Centre for Architecture,
Montreal

SELECT BIBLIOGRAPHY SINCE 2005

2012
Robert Burley, *Disappearance of Darkness:
Photography at the End of Analogue Era* (New York:
Princeton Architectural Press, 2012).

2009
Gaëlle Morel, *The Spaces of the Image* (Montréal:
Le Mois de la Photo à Montréal, 2009).
Dale Sheppard, *Flight Dreams* (Halifax: Art Gallery
of Nova Scotia, 2009).

2006
MaryAnn Camilleri, *Carte Blanche: Volume I* (Toronto:
Magenta Foundation, 2006).

2005
Lisa Rochon, "Up North: Where Canada's Architecture
Meets the Land, Toronto," *Key-Porter* (2005):
2–3, 147.

STAN DOUGLAS

Born in 1960, Vancouver
Lives and works in Vancouver

EDUCATION

Diploma of Visual Art, Emily Carr College
of Art + Design, Vancouver, 1982

SELECTED SOLO EXHIBITIONS SINCE 2005

2014
Helen Lawrence, Arts Club Theatre Company,
Vancouver; Münchner Kammerspiele, Munich;
Edinburgh International Festival; Canadian
Stage, Toronto
Scotiabank Photography Award, Ryerson Image
Centre, Ryerson University, Toronto (catalogue)
Stan Douglas, The Fruitmarket Gallery,
Edinburgh (catalogue)

2013
Photographs 2008-2013, Carré d'Art - Musée d'Art
Contemporain, Nîmes, France
Mise en scène, Haus der Kunst, Munich; Nikolaj
Kunsthal, Copenhagen; Irish Museum of Art,
Dublin (catalogue)
Abandonment and Splendour, Canadian Cultural
Centre, Paris

2012
New Pictures 7: Stan Douglas, Then and Now,
Minneapolis Institute of Arts, Minnesota

2011
Entertainment: Selections from Midcentury Studio,
The Power Plant, Toronto (catalogue)

2007
Past Imperfect: Werke/Works 1986-2007,
Staatsgalerie Stuttgart, Württembergischer
Kunstverein, Stuttgart (catalogue)

2006
Klatsassin, Vienna Secession (catalogue)

2005
Inconsolable Memories, Joslyn Art Museum, Omaha,
Nebraska; Morris and Helen Belkin Art Gallery,
University of British Columbia, Vancouver; Art Gallery
of York University, Toronto; The Studio Museum in
Harlem, New York (catalogue)

SELECTED GROUP EXHIBITIONS SINCE 2005

2012
Blues for Smoke, Museum of Contemporary Art,
Los Angeles; Whitney Museum of American Art,
New York; Wexner Center for the Arts, Columbus,
Ohio (catalogue)

2011
4th Moscow Biennale: Rewriting Worlds (catalogue)

2010
*Haunted: Contemporary Photography/Video/
Performance*, Solomon R. Guggenheim Museum,
New York (catalogue)

2008
*The Cinema Effect: Illusion, Reality, and the Moving
Image, Part I: Dreams*, Hirshhorn Museum and
Sculpture Garden, Washington, D.C. (catalogue)

2006
*Beyond Cinema: The Art of Projection. Films, Videos,
and Installations from 1963 to 2005*, Hamburger
Bahnhof - Museum für Gegenwart, Berlin (catalogue)

SELECTED BIBLIOGRAPHY SINCE 2005

2012
Ian Farr, *Memory: Documents of Contemporary*
(London: Whitechapel Gallery; Cambridge:
The MIT Press, 2012).
Monika Szewczyk, "Midcentury Disco," *Mousse*
(February 2012): 54–65.

2011
Stan Douglas: Abbott & Cordova, 7 August 1971
(Vancouver: Arsenal Pulp Press, 2011).
Tommy Simoens, *Stan Douglas: Midcentury Studio*
(Antwerp: Ludion Publishers, 2011).

2007
Robert Enright, "Double Take," *frieze*
(September 2007): 168–75.

2006
Stan Douglas (Cologne: DuMont Literatur und
Kunst Verlag, 2006).

SELECTED ARTIST WRITINGS SINCE 2005

2011
"Midcentury Studio," *Stan Douglas: Midcentury
Studio*, ed. Tommy Simoens, (Antwerp: Ludion
Publishers, 2011), 6–7.
"500 Words: Stan Douglas," *artforum.com*
(April 18, 2011).

2009
"Afterword," *Vancouver Anthology: The Institutional
Politics of Art*, ed. Stan Douglas (Vancouver:
Talonbooks, 2009).
"The Artists' Artists," *Artforum* (December 2009): 98.
"Foreword," *Art of Projection*, eds. Stan Douglas and
Christopher Eamon, (Ostfildern: Hatje Cantz Verlag,
2009), 6–9.

2006
"Regarding Shadows," *Beyond Cinema: The Art of
Projection. Films, Videos, and Installations from
1963 to 2005* (Ostfildern: Hatje Cantz Verlag; Berlin:
Hamburger Bahnhof - Museum für Gegenwart,
2006), 17–20.

"1,000 Words: Stan Douglas Talks About *Klatsassin*,
2006," *Artforum* (October 2006): 232–33.

"Television Talk," *Art Recollection: Artists' Interviews
and Statements in the Nineties*, Gabriele Detterer ed.
(Ravenna, Italy: Danilo Montanari Editore; Florence:
Exit & Zona Archives, 2006).

BABAK GOLKAR

Born in 1977, Berkeley
Lives and works in Vancouver

EDUCATION

Master of Fine Arts, University of British Columbia,
Vancouver, 2006
Bachelor of Fine Arts, Emily Carr Institute of Art +
Design, Vancouver, 2003

SELECTED SOLO EXHIBITIONS SINCE 2005

2014
Of Labour, Of Dirt, Sazmanab Center for
Contemporary Art, Tehran (catalogue)
The Return Project, The Third Line, Dubai
Time To Let Go..., Vancouver Art Gallery's Offsite,
Vancouver

2013
Dialectic of Failure, West Vancouver Museum,
West Vancouver
Ground for Standing and Understanding, VOLTA NY
Featured Project, New York (catalogue)

2012
Parergon, Sharjah Contemporary Art Museum,
Sharjah
Mechanisms of Distortion (commissioned
installation), Victoria and Albert Museum, London

2011
Parergon, The Third Line, Dubai (catalogue);
CSA Space, Vancouver
Black Cube: Moving Toward the Abstract Light,
Sanatorium, Istanbul

SELECTED GROUP EXHIBITIONS SINCE 2005

2015
Crisis of History – Beyond History, Framer Framed,
Amsterdam
Common Grounds, Museum Villa Stuck, Munich
Heaven and Hell, Fondation Boghossian – Villa
Empain, Brussels

2014
L'avenir: 9ᵗʰ, La Biennale de Montréal, Musée d'art
Contemporain de Montréal
La Route Bleue, Musée National Adrien Dubouché,
Limoges, France

2013
La Route Bleue, Fondation Boghossian –
Villa Empain, Brussels

2012
Jameel Prize Exhibition, Casa Árabe, Madrid;
l'Institut du monde arabe, Paris; Victoria and
Albert Museum, London

SELECTED BIBLIOGRAPHY SINCE 2005

2014
Dr. Abbas Daneshvari, *Amazingly Original:
Contemporary Iranian Art at Crossroads* (California:
Mazda Publishers, 2014).

2012
Gareth James, "Grounds for Standing and
Understanding," *Art Forum* (May 2012): 318.
Vali, Murtaza, "Babak Golkar: Funny Frames," *Harper's
Bazaar Art* (January 2012): 70–74.

2010
Behnam Nateghi, "Interview with Babak Golkar,"
Voice of America (January 2010).

2009
Annette Hurtig, "House of Sulphur: An Extended
Dérive," *The Capilano Review* (Spring 2009): 120–27.

GEOFFREY JAMES

Born in 1942, St. Asaph, Clwyd, Wales
Lives and works in Toronto, Ontario

EDUCATION

Bachelor of Arts and Master of Arts, Modern History,
University of Oxford, 1960–64

SELECTED SOLO EXHIBITIONS SINCE 2005

2015
Waiting for Fidel, Slought Foundation, Philadelphia

2014
Inside, Agnes Etherington Art Centre, Queen's
University, Kingston; Glenbow Museum,
Calgary (catalogue)

2011
The Nanton Project, University of Lethbridge
(catalogue)

2008
Field Notes, Kitchener-Waterloo Art Gallery
(artist's book)
Utopia/Dystopia, National Gallery of Canada,
Ottawa (catalogue)

SELECTED GROUP EXHIBITIONS SINCE 2005

2014
Punctum, Salzburger Kunstverein, Salzburg
(catalogue)

2013
More than two, let it make itself, The Power Plant,
Toronto (catalogue)
Auto-Motive, The World from the Windshield,
Oakville Galleries

2012
Photography in Mexico, San Francisco Museum
of Modern Art

2011
Imperfect Health, The Medicalization of Architecture,
Canadian Centre for Architecture, Montreal
(catalogue)

2009
*Into the Sunset: Photography's Image of the American
West*, Museum of Modern Art, New York (catalogue)

2008
The Tree: From the Sublime to the Social, Vancouver
Art Gallery
Transformation AGO, Art Gallery of Ontario, Toronto
Is There a There There?, Oakville Galleries, Museum
London (catalogue)
The Wide Open, Missoula Art Museum, Montana
(catalogue)

2007
Le musée côté jardin, Musée d'art et d'histoire,
Saint-Brieuc, France

2006
Landscape: Recent Acquisitions, Museum of Modern
Art, New York

2005
*Contemporary Photography and the Garden: Deceits
and Fantasies*, Middlebury College Art Museum,
Vermont; Parrish Art Museum, Southampton, New
York; Columbia Museum of Art, South Carolina;
Tacoma Art Museum, Washington; Cheekville
Museum of Art, Nashville, Tennessee; Hudson
River Museum, New York; Delaware Art Museum,
Wilmington (catalogue)

SELECTED BIBLIOGRAPHY SINCE 2005

2015
Sharday Masurinjohn, "Locked Up," *Canadian Art*
(Winter 2015).

2014
William Ewing, *Landmarks* (London: Thames and
Hudson, 2014).

2013
Kenneth Hayes, "Boom Town Blues," *Prefix Photo*,
no. 27 (2013).

2011
Josephine Mills and James Coutts, *Safe Home*
(Lethbridge: University of Lethbridge Art Gallery,
2011).

2009
Eva Respini, *Into the Sunset, Photography's
Image of the American West*
(New York: Museum of Modern Art, 2009).

2008
Michael Mitchell, "A Photographer's Journey,"
Canadian Art (Fall 2008).

SELECTED ARTIST WRITINGS SINCE 2005

2012
"Josef Sudek and the Panoramic Camera," *Josef
Sudek, The Legacy of a Deeper Vision*, ed. Maia Sutnik
(Chicago: Hirmer Publishers, 2012).

2006
Toronto (Vancouver: Douglas & McIntyre, 2006).

BRIAN JUNGEN

Born in 1970, Fort St. John, British Columbia
Lives and works in North Okanagan, British Columbia

EDUCATION

Diploma of Visual Art, Emily Carr Institute of Art +
Design, Vancouver, 1992

SELECTED SOLO EXHIBITIONS SINCE 2005

2014
Brian Jungen and Duane Linklater: Modest Livelihood,
Edinburgh Festival; VOX, Montreal

2013
Brian Jungen, Hannover Kunstverein
Brian Jungen, Bonner Kunstverein
Brian Jungen and Duane Linklater: Modest Livelihood,
Catriona Jeffries Gallery, Vancouver; Art Gallery of
Ontario, Toronto

2012
Brian Jungen and Duane Linklater: Modest Livelihood,
Walter Phillips Gallery, The Banff Centre; Logan
Center Gallery, University of Chicago

2011
Brian Jungen: Tomorrow, Repeated, Art Gallery
of Ontario, Toronto

2009
Brian Jungen: Strange Comfort, Smithsonian
Institute – National Museum of the American Indian,
Washington, D.C.

2007
Witte de With, Rotterdam (catalogue)

2006
Brian Jungen, Tate Modern, London
Brian Jungen, Vancouver Art Gallery (catalogue)

2005
Brian Jungen, New Museum, New York

SELECTED GROUP EXHIBITIONS SINCE 2005

2013
Sakahàn, National Gallery of Canada, Ottawa
(catalogue)

2012
Beat Nation: Art, Hip Hop and Aboriginal Culture,
Vancouver Art Gallery; Musee d'art contemporain
de Montréal; The Power Plant, Toronto; Kamloops
Art Gallery
dOCUMENTA (13), Kassel
Shanghai Biennial
Builders: Canadian Biennial 2012, National Gallery
of Canada

2010
Hard Targets, Wexner Center for the Arts, Columbus

2008
The Martian Museum of Terrestrial Art, Barbican Art
Gallery, London
Sydney Biennale

2007
Lyon Biennial

SELECTED BIBLIOGRAPHY SINCE 2005

2013
Gregory Minissale, *The Psychology of Contemporary
Art* (Cambridge: Cambridge University Press, 2013).

2012
Charlotte Townsend-Gault, "Skin Deep," *Anthology
of Exhibition Essays 2010/2011* (Vancouver:
CJ Press, 2012).
Brian Jungen, *Facing History: Portraits of Vancouver*
(Vancouver: Presentation House Gallery, 2012).
Karen Kramer Russel et al., *Shapeshifting:
Transformations in Native American Art* (Salem:
Peabody Essex Museum; New Haven: Yale University
Press, 2012).

2009
Lindsay Brown, "Brian Jungen," *Vitamin 3-D: New
Perspectives in Sculpture and Installation* (London:
Phaidon, 2009).

2008
Candice Hopkins, "Brian Jungen: New Monuments,"
Anthology of Exhibition Essays 2006/2007
(Vancouver: CJ Press, 2008).

DUANE LINKLATER

Born 1976, Moose Factory, Ontario
Lives and works in North Bay, Ontario

EDUCATION

Master of Fine Arts, Milton Avery Graduate School
of the Arts at Bard College, New York, 2012
Bachelor of Fine Arts, University of Alberta,
Edmonton, 2005
Bachelor of Native Studies, University of Alberta,
Edmonton, 2003

SELECTED SOLO EXHIBITIONS SINCE 2005

2015
Salt 11: Duane Linklater, Utah Museum of Fine Arts,
Salt Lake City (catalogue)

2014
ICA@50: It means it is raining, Institute
of Contemporary Art, Philadelphia

2013
Decommision, MacLaren Art Centre, Barrie, Ontario
Brian Jungen and Duane Linklater: Modest Livelihood,
Art Gallery of Ontario, Toronto; Catriona Jeffries
Gallery, Vancouver

2012
Brian Jungen and Duane Linklater: Modest Livelihood,
Logan Center Gallery at the Reva and David Logan
Center for the Arts, University of Chicago
Beothuck Building, Or Gallery, Vancouver
Raspberry Cargo, Family Business Gallery, New York
Brian Jungen and Duane Linklater: Modest Livelihood,
Walter Phillips Gallery, The Banff Centre, presented
in collaboration with dOCUMENTA (13), Kassel
(catalogue)
Untitled (A Blueberry Garden for Bard College), CCS
Bard at the Hessel Museum Annandale on Hudson,
New York

2011
Journey Through, White Water Gallery,
North Bay, Ontario

2009
Tiny Resident, University of Delaware, Newark

SELECTED GROUP EXHIBITIONS SINCE 2005

2015
Folklore and Other Panics, The Rooms, St. Johns,
Newfoundland

2014
Where Do I End and You Begin?, Edinburgh Art
Festival, City Art Centre (catalogue)
Unstuck In Time, Te Tuhi Centre for the Arts, Auckland

2013
Sobey Art Award Exhibition, Art Gallery of Nova
Scotia, Halifax
Beat Nation: Art, Hip Hop and Aboriginal Culture,
Vancouver Art Gallery; Musee d'art contemporain
de Montréal; The Power Plant, Toronto; Kamloops
Art Gallery
Fiction / Non Fiction, Esker Foundation, Calgary
(catalogue)

2010
About Face, Art Gallery of Alberta, Edmonton

SELECTED BIBLIOGRAPHY SINCE 2005

2014
Maggie Groat, *Drinking the Lake* (Toronto: Art
Metropole, 2014).
"Map Screen | The Anthropology Effect," *MAP* (2014).

2013
Virginie Bourget, *Chasse et Chassé* (Gétigné-Clisson:
Domain de la Garenne Lemot, 2013).
Clint Burnham, "Duane Linklater," *Canadian
Art* (Spring).
Milena Tomic, "Toronto, Duane Linklater,
Susan Hobbs," *Art In America* (December).

139

CATHERINE OPIE

Born in 1961, Sandusky, Ohio
Lives and works in Los Angeles, California

EDUCATION

Master of Fine Arts, CalArts, Valencia, 1988
Bachelor of Fine Arts, San Francisco Art Institute, 1985

SELECTED SOLO EXHIBITIONS SINCE 2005

2015
Catherine Opie: Portraits and Landscapes, Wexner Center for the Arts, Columbus

2014
The Gang: Photographs by Catherine Opie, Walker Art Gallery, Liverpool

2013
Catherine Opie, Regen Projects, Los Angeles

2012
Twelve Miles to the Horizon: Sunrises and Sunsets, Long Beach Museum of Art
BROADWAY BILLBOARD: Catherine Opie, Untitled (Stump Fire #4), Socrates Sculpture Park, New York

2011
Catherine Opie: Empty and Full, The Institute of Contemporary Art, Boston

2010
Catherine Opie, Portland Art Museum
Catherine Opie: Figure and Landscape, Los Angeles County Museum of Art

2008
Catherine Opie: American Photographer, Guggenheim Museum, New York (catalogue)

2006
1999 & In and Around Home, Aldrich Museum, Ridgefield, Connecticut; The Orange County Museum of Art, Newport Beach; Cleveland Museum of Contemporary Art; Weatherspoon Art Museum, Greensboro, North Carolina (catalogue)
Catherine Opie: Chicago, Museum of Contemporary Art Chicago (catalogue)

SELECTED GROUP EXHIBITIONS SINCE 2005

2015
Perfect Likeness: Photography and Composition, Hammer Museum, Los Angeles

2014
Concrete Infinity, Museum of Contemporary Art, Los Angeles
After Our Bodies Meet: From Resistance to Potentiality, The Leslie-Lohman Museum of Gay and Lesbian Art, New York
Fan the Flames, Art Gallery of Ontario, Toronto

2013
I, You, We, Whitney Museum of American Art, New York

2012
Self-portraits, Louisiana Museum of Modern Art, Humlebaek, Denmark (catalogue)
An Orchestrated Vision: The Theater of Contemporary Photography, Saint Louis Art Museum

SELECTED BIBLIOGRAPHY SINCE 2005

2011
John Kelsey and Brian Phillips, eds., *Rodarte, Catherine Opie, Alec Soth* (Zürich: JRP Ringier, 2011).
Eileen Myles, *Catherine Opie: Inauguration* (New York: Gregory R. Miller & Co, 2011),

2011
Jill Medvedow and Anna Stothart, *Catherine Opie: Empty and Full* (Ostfildern, Germany: Hatje Cantz, 2011).

2008
Ann Goldstein, Rebecca Morse and Paul Schimmel, *This is Not to be Looked At* (Los Angeles: Museum of Contemporary Art, 2008).
Andrea Bowers and Catherine Opie, *Andrea Bowers & Catherine Opie (Between Artists)* (New York: A.R.T. Press, 2008).

2006
Catherine Opie: Chicago (American Cities) (Chicago: Museum of Contemporary Art, 2006).
Catherine Opie: 1999 / In and Around Home (Ridgefield: The Aldrich Contemporary Museum of Art; Newport Beach: Orange County Museum of Art, 2006).
Vitamin Ph: New Perspectives in Photography (London: Phaidon Press, 2006).

AMIE SIEGEL

Born in 1974, Chicago
Lives and works in New York

EDUCATION

Master of Fine Arts, The School of the Art Institute
of Chicago, 1999
Bachelor of Arts, Bard College, Annandale-on-
Hudson, New York, 1996

SELECTED SOLO EXHIBITIONS SINCE 2005

2015
Amie Siegel, Villa Stuck, Munich (catalogue)
Amie Siegel: Provenance, The Museum of Applied
Arts, Vienna (catalogue)
Amie Siegel: The Architects, Storefront for Art &
Architecture, New York

2014
Amie Siegel: Provenance, The Metropolitan Museum
of Art, New York (catalogue)
Amie Siegel: Provenance, University of Michigan
Museum of Art, Ann Arbor (catalogue)
Amie Siegel: Provenance, Center for Contemporary
Art, Tel Aviv
Winter, Ratio 3, San Francisco

2013
Amie Siegel: Provenance, Simon Preston Gallery,
New York

2012
Black Moon, AMOA-Arthouse, Austin

2011
Amie Siegel. Part 1: Black Moon, Kunstmuseum
Stuttgart (catalogue)

2007
Berlin Remake, Carpenter Center for the Visual Arts,
Harvard University, Cambridge

SELECTED GROUP EXHIBITIONS SINCE 2005

2015
Wohnungsfrage, Haus der Kulturen der Welt, Berlin
(catalogue)
Production Routes, Tel Aviv Museum of Art

2014
Pop Departures, Seattle Art Museum (catalogue)
Utopia for Sale?, MAXXI National Museum of XXI
Century Arts, Rome
Infinite City, Zabludowicz Collection, London;
CCA Wattis, San Francisco

2013
The 5ᵗʰ Auckland Triennial: If You Were to Live Here,
Auckland Art Gallery (catalogue)
Approximately Infinite Universe, Museum of
Contemporary Art, San Diego

2010
The Talent Show, Walker Art Center, Minneapolis;
MoMA PS1, New York; Henry Art Gallery, Seattle
2010 Foster Prize, The Institute for Contemporary
Art, Boston

2009
The Russian Linesman, Hayward Gallery,
London (catalogue)

2008
Whitney Biennial, Whitney Museum of American
Art, New York (catalogue)

SELECTED BIBLIOGRAPHY SINCE 2005

2015
Rattanamol Singh Johal, "Amie Siegel: *Provenance*,"
Art Papers (January 2015).

2014
Andrea Picard, "Film/Art | Provenance: The Artist
(Amie Siegel)," *Cinema Scope* (May 2014).
Mark Godfrey, introduction to "1000 Words:
Provenance," *Artforum* (January 2014).
Lynn Hershman Leeson, "Amie Siegel by Lynn
Hershmann Leeson," *Bomb* (Winter 2013–14).

2013
Kari Rittenbach, "Valued Objects, High Returns,"
Texte zur Kunst (December 2013).
Lauren O'Neill-Butler, "Amie Siegel at Simon Preston
Gallery," *Artforum* (December 2013).
Scott MacDonald, "Amie Siegel," *American
Ethnographic Film and Personal Documentary: The
Cambridge Turn* (Berkeley: University of California
Press, 2013).

2012
William Smith, "Cross-Pollination," *Artforum.com*,
June 6, 2012.
Barbara Mennel, "The Architecture of Heimat in the
Mise-en-Scene of Memory: Amie Siegel's *Berlin
Remake*," *Heimat: At the Intersection of Space and
Memory*, eds. Friederike Eigler and Jens Kugele (Berlin:
DeGruyter, 2012).

2011
Aaron Kunin, "Space and Place in Two Video
Installations by Amie Siegel," *The Highlights*
(February 4, 2011).

2010
Audrey Illouz, "Another Point of View," *Frieze*
(November 22, 2010).
Phil Collins and Sinisa Mitrovic, *Auto-Kino!* (Berlin:
Temporäre Kunsthalle Berlin, 2010).

2009
Michael Wang, "Form and Function," *Artforum.com*,
April 10, 2009.

2008
Xavier Laboulbenne, Aljoscha Weskott, *Fracture:
Conversations on Memory in the Berlin Republic*
(Berlin: B_Books Verlag, 2008).

2006
Sabine Himmelsbach and Barbara Filser, *Amie Siegel:
Berlin Remake* (Frankfurt: Revolver Archiv
für Aktuelle Kunst, 2006).

SELECTED ARTIST WRITINGS SINCE 2005

2014
"Mirroring," *Speculation*, eds. Carin Kuoni, Pr.em
Krishnamurthy and Vyjayanthi Rao (Durham: Duke
University Press, 2014).
"Factories and The Factory," *A Companion to Jean-
Luc Godard*, eds. Tom Conley and T. Jefferson Kline
(Hoboken: Wiley Blackwell, 2014).

2012
"Ciné-Constellation," *Revolver: Manifestheft 26*
(2012).
"Object Relations," *Draw it With Your Eyes Closed*
(Brooklyn: Paper Monument, 2012).

2011
"*À Rebours* | Against the Grain," *Film: Tacita Dean*
(London: Tate Publications, 2011).
"Artist Project," *Cabinet*, no. 41–43 (2011).

2010
"Author, Author," artist project in *Input*, vol. 2 (2010).

141

PHOTO CREDITS